JOURNAL REVOLUTION

RISE UP AND CREATE!
ART JOURNALS, PERSONAL MANIFESTOS AND OTHER ARTISTIC INSURRECTIONS

LINDA WOODS AND KAREN DININO

NORTH LIGHT BOOKS
CINCINNATI, OHIO

Journal Revolution. Copyright© 2007 by Linda Woods and Karen Dinino. Manufactured in China. All rights reserved. The artwork in the book is for personal use of reader. By permission of the author and publisher, it may be recreated, but under no circumstances may it be resold or republished. It is permissible for the purchaser to make the projects contained herein and sell them at fairs, bazaars and craft shows. No other part of this book may be reproduced in any form or by any electronic or mechanical means including information storage and retrieval systems without permission in writing from the publisher, except by a reviewer, who may quote a brief passage in review. Published by North Light Books, an imprint of F+W Publications, Inc., 4700 East Galbraith Road, Cincinnati, Ohio 45236. (800) 289-0963. First edition.

11 10 09 08 07 5 4 3 2 1

Distributed in Canada by Fraser Direct
100 Armstrong Avenue
Georgetown, ON, Canada L7G 5S4
Tel: (905) 877-4411

Distributed in the U.K. and Europe by David & Charles
Brunel House, Newton Abbot, Devon, TQ12 4PU, England
Tel: (+44) 1626 323200, Fax: (+44) 1626 323319
E-mail: postmaster@davidandcharles.co.uk

Distributed in Australia by Capricorn Link
P.O. Box 704, S. Windsor, NSW 2756 Australia
Tel: (02) 4577-3555

Library of Congress Cataloging-in-Publication Data

Woods, Linda.
 Journal revolution : rise up and create art journals, personal manifestos and other artistic insurrections / Linda Woods and Karen Dinino.
 p. cm.
 Includes index.
 ISBN-13: 978-1-58180-995-4 (pbk. : alk. paper)
 1. Handicraft. 2. Scrapbook journaling. I. Dinino, Karen. II. Title.
 TT157.W6364 2008
 745.593--dc22

 2007007639

Digital brushes and imagery used in this book courtesy of www.designerdigitals.com, www.gomedia.us/arsenal and www.brushes.obsidiandawn.com.

fw
F+W PUBLICATIONS, INC.
WWW.FWBOOKSTORE.COM

ABOUT THE AUTHORS

Sisters Linda Woods and Karen Dinino are the authors of *Visual Chronicles: The No-Fear Guide to Creating Art Journals, Creative Manifestos and Altered Books*. Their fearless, no-rules approach to art journaling has been featured on *The View*, national television and in magazines and newspapers nationwide. Linda's vibrant artwork, unique journals and articles about the creative process have appeared in books, magazines, art calendars and exhibits worldwide. Karen Dinino practices employment law, trains executives to write and to speak well and formerly was a professional journalist. Together, Linda and Karen teach workshops designed to help artists communicate better with words, and to help writers communicate better with art—the combination creating powerful, evocative, limitless visual journals. When they aren't traveling the globe, snapping photos of bold expression from the subways to the skies, Karen and Linda live in southern California. To the delight of their husbands, they no longer live together. Linda lives with her husband, Dustin, and Karen lives with her husband, Bill, and their two children, Emily and Brent. Linda and Karen can usually be found instant messaging each other in the wee hours of the night.

To learn more, visit *WWW.JOURNALREVOLUTION.COM*. To see more of Linda's inspirational, revolutionary artwork, visit *WWW.COLORMETRUE.COM*. For guidance on crossing the legal minefield facing employers, visit Karen at *WWW.EMPLOYMENTOR.NET.*

EDITOR/TONIA DAVENPORT DESIGNER/MARISSA BOWERS
PRODUCTION COORDINATOR/GREG NOCK
PHOTOGRAPHERS/CHRISTINE POLOMSKY AND AL PARRISH
STYLIST/JAN NICKUM

DEDICATION

FOR DUSTIN, WHO NEVER HAD ANY DOUBT; FOR KAREN, WHO IS ALWAYS BY MY SIDE, EVEN WHEN SHE ISN'T; AND FOR ME, BECAUSE DEDICATION TO YOURSELF REALLY DOES MATTER.

—LINDA

FOR BILL, EMILY AND BRENT, WHO GET TO LIVE WITH MY CROOKED LINES; FOR LINDA, WHO HAS ALWAYS READ BETWEEN THE LINES; AND FOR ME, BECAUSE IT TAKES SELF-DEDICATION TO DRAW ANY LINES.

—KAREN

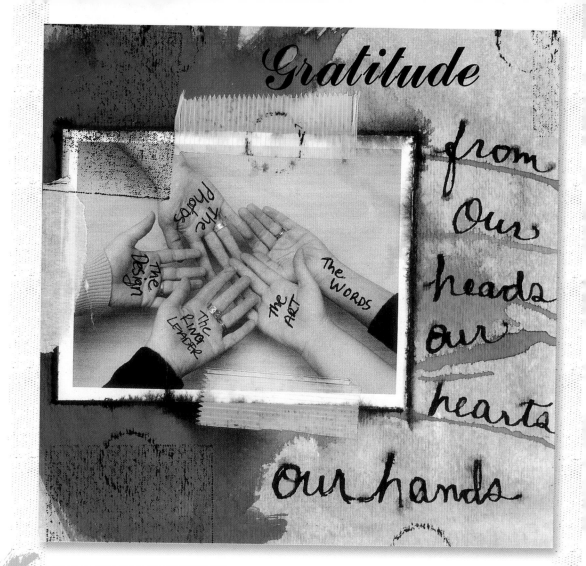

Gratitude from our heads our hearts our hands

The Photos
The Design
The Fine Leader
The Art
The Words

ACKNOWLEDGMENTS

Thank you, Rosie O'Donnell, for "getting" us, for cheering us up and on and for speaking your truth in art. You are our hero. Lee Goldberg and Tod Goldberg, our often-ribbed and much-loved brothers: Thank you for nudging, nagging, prodding and believing. Thanks, Mom, for teaching us all to speak our minds. Nana, we love you all to pieces! Many thanks to Julie Kornack, Barbara Karm and Sherrie Lewis for your never-ending support and laughter, and for always being interested in what we have to say. Lita Weissman and Suzi Finer, thank you for your boundless energy and encouragement. Much gratitude to Tonia Davenport, Marissa Bowers, Jessica Strawser and Christine Polomsky, the North Light team whose creativity and humor spark artistic revolutions in all lucky enough to know (and dine with!) them.

CONTENTS

our daily walk to
starbucks was a
spiritual experience.

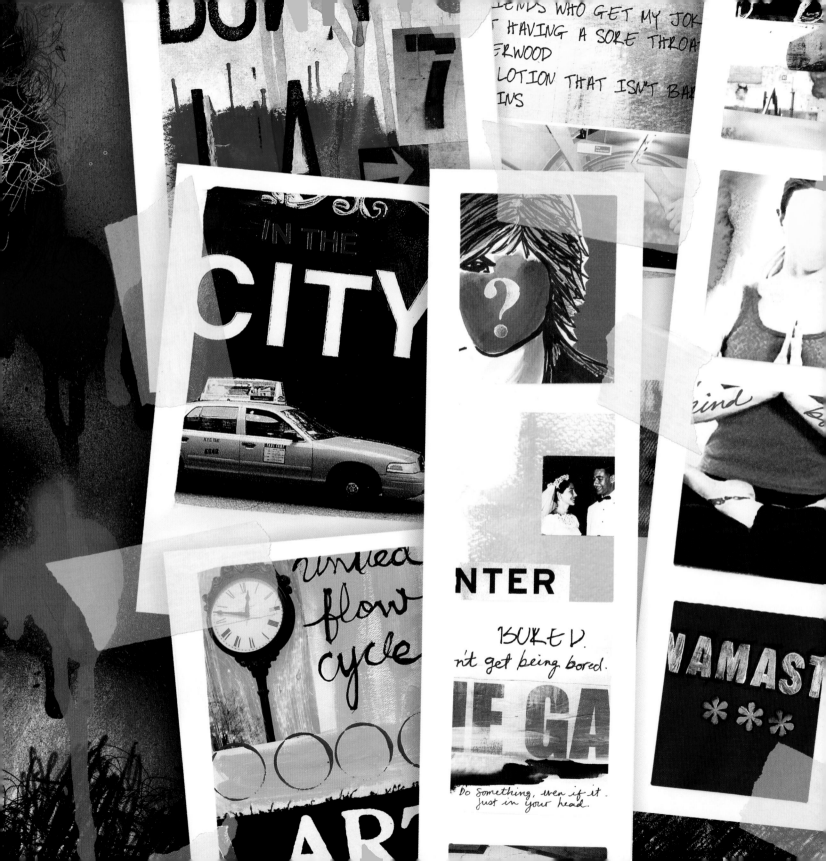

Rise Up and Create!

Listen. There's a beat within you, and it is more than your heart. It's the sound of your personal rhythm, the words you shout in your bones, the leaps you dance in your dreams, the grief you hide behind your smiles. Embrace that beat and start creating to it. Let it become a beautiful symphony before your eyes. Rise up and CREATE.

Truth *is* beauty. Art journals are visual expressions of the true noise, colors, clutter, emotions and people within us. Anything is possible on the pages of our journals, and only we set the limits. So . . . what if we refuse to limit our expression? What if we drop right into the deepest parts of our noise and clutter, and journal from our inner city?

This revolutionary approach to art journaling celebrates our rough edges, crumbling facades, poetic visions and bold proclamations. We'll overthrow the old notions of a journal as either a plain-papered home for safe thoughts, or a "pretty" book created from premade project kits. We are done with regimented writings in school notebooks, and we demand the freedom to travel wherever we want on our inner Metro Line. We'll explore and capture the different neighborhoods within us— our urban, edgy areas; our quirky art loft region; our Central Park, full of soap boxes and speakers; our graffiti-splattered bus stops; our jazz-and-blues quarter, where we pour out our soul; even our tourist traps, with photo booths and comfort food aplenty. No borders, no boundaries: truth, journaled, wherever we find it.

Come, take the A-Train to downtown You. The ticket is cheap. It could be a scent from your past, a raw nerve, a haunted dream, a thriving passion or a gift you've longed to give. Grab your mess kit. We're gonna start a Journal Revolution.

STAGE ONE
Gather Your Forces

Your ideas and ideals are the main force behind this revolution. We like to use common, household art and craft supplies in perhaps uncommon ways. There are many tools and methods to enhance your creativity right in you, and right in your own home, right now. It is simple and inexpensive to revolutionize the appearance of your journal pages to reflect a range of emotions, as we explain in the Tactical Maneuvers section (page 11). Craft and discount stores also are filled with fun materials for creating texture, movement and depth on your pages.

Paints and Inky Paints

No need to get fancy and expensive. We like inexpensive acrylic craft paints. If you have spray paint in your garage, go get it! Borrow your kids' blow pens, or fearlessly go buy your own; they make great paint effects. To get the look of ink with paint, we like Dr. Ph. Martin's Radiant Concentrated Watercolors, in dropper bottles. These are easy and comfortable to use, like your other Doc Martens, but less clunky.

Ink and Ink Pads

Writing with ink looks expressive and allows you to do lettering with a brush. We like dye-based liquid ink. Ink pads are great for more than stamping—you can paint with them and make interesting texture. You just press your ink pad right on your paper, with varying pressure. Layer the ink, too, if you want. We tend to use dye-based ink pads for stamping and sponging. We particularly like Memories pads.

Adhesives

All you need is a glue stick, really. We also use double-sided tape, school glue (Elmer's) or Mod Podge when we have them. Tape in different textures, widths and colors is an excellent decorative element, too. We like clear packing tape, duct tape, masking tape and first-aid tape.

Pens and Pencils

We like Sharpie fine-point, permanent ink pens for writing. They come in a rainbow of colors. For writing in white, we love the Liquid Paper correction fluid pen. When we want our handwritten lettering to drip or fade, we use nonpermanent ink markers. Any pencil is fine, too; be guided by the feelings you want to express and which tool best suits them.

Brushes and Applicators

For writing, we use a round sable brush. For painting large surfaces, a flat nylon or foam brush. For textures, a bristle brush. If you don't have brushes, use makeup applicators, cotton swabs, cosmetic sponges or even your fingers!

Stamping

Alphabet stamps in a variety of sizes make journaling easier. An assortment of rubber-stamp images inspires you and "draws" for you. Make stamps from common "junk" around your house: medicine bottle lids, eyedrop bottle lids, soda tabs, cardboard, vegetables, egg cartons, bubble wrap, leaves . . . anything with a shape or texture you like.

Stencils

The easiest way to add texture is with stencils. Keep a few stencils of basic geometric shapes in graduating sizes. You can get stencil packs for collaging at craft stores and can even use household items like notebook paper holes for dots or mesh drywall tape for grids. You can also use hole punches to make your own stencils.

Papers

Journal on the paper you have. If all you have is binder paper, use it. You do not have to have special paper to do visual journaling. We use anything from sticky notes to graph paper to water-color paper to scrapbook papers to cardboard. Scrapbook papers and printed papers enhance your journal pages with patterns, faux textures and even fibers.

Blank Journals

Don't stress about the blank book. IF you want a bound journal book, lovely. Have a journal book. If it is going to haunt you, forget about the journal. Just express yourself on any surface, keeping within the law, and then you can put your loose pages in a binder, book or box later. Spiral-bound journals that open flat are the easiest to use.

Spray Bottle

Water is your friend. Get a little spray bottle so you can spritz your art for texture. Spritz your face, too, if one of those hot flashes comes.

Photos

Take lots of pictures. Use any kind of camera and photograph yourself and the everyday things that make up your life: your family, friends, food, garden, pets, favorite tree, keyboard, the entrance to your parking garage at work. All of these images can wind up in your journal pages.

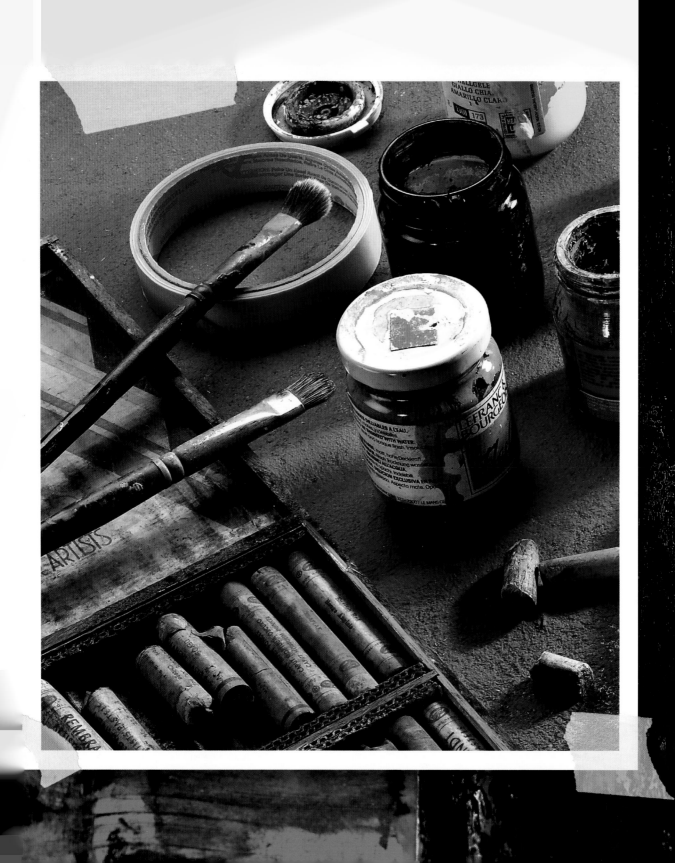

STAGE TWO
Tactical Maneuvers

When the sound inside you is disso- nance, ready-made decorative papers and prescribed layouts won't do. We need "tactical maneuvers" designed for our full range of experiences and emotions, ready to leap tall buildings and scrawl over bridges. If you are used to creating archival scrapbooks or to writing pages a day in journals, take note: This type of art journaling has a different purpose and a different method. When creating journals that are uniquely yours, you are free to use color, paper and words in ways as unconventional as your thoughts. The media we choose for our creation, from picking ink over paint to adhering with a staple or glue, affects the emotion we convey. Therefore, the most important tactical maneuver is letting go. Let go of convention, let go of expectations, let go of what you think should be. Breathe deeply and feel what your emotion looks like.

Revolutions challenge conventional thought, and this one is no different. Conventional wisdom is that you do not paint on a photo. You do not tear pic- tures. You do not have crooked lines, and if your paint drips—YIKES!—you start all over. Ahhh, but in our ever- spinning world, we do have crooked lines, torn images, drips here and there, shatters. Our journals must be safe places to depict this world.

We want our art to feel like the frenzy singing or screaming inside us. When you try to make all of your feel- ings "pretty," you wind up looking at your journal page and wondering what went wrong. The page seems "wrong" because clean lines, cheery colors, straight edges and polka-dot borders do not convey frenzy, no matter what words you put on that page. Taping a photo to a page may seem sloppy, yet the look of frayed masking tape expresses raw emotion. Sand- ing a photo sounds like ruin- ing a photo until you see a weathered image that perfectly matches your hazy memory.

Just as the neighborhoods in your city look different, the neighborhoods in you look dif- ferent, too. To capture all your truth and beauty, you need only a few simple techniques. Use the tech- niques that intuitively feel right for the moment, thought or emotion being expressed. You do not have to use all the techniques at once! Sim- ple pages speak volumes, and cluttered pages may hide you. Now, let's get the look.

HAVE NO FEAR!

Don't forget your flashes of brilliance! Just as our hairdresser keeps cards of our color formula, or as we jot notes onto our favorite recipes, create a catalogue of your best techniques, textures and color combos. Make 4" × 6" (10cm × 15cm) technique sample cards. Bind your sample palette with fiber or a brad and add to it as you experiment and play.

YOU GOT THE LOOK...

→ → →

Moving emotion from gut to page is easy once you see your options. Your journal pages "speak" through several elements, each presenting choices that allow you to create exactly the mood and tone you want. For example, when planning a journal entry, consider these elements and how you might want to use them.

Color

Color can be the focal point or an accent on your page. Ask yourself: What color feels like the mood, person, event or place I am journaling about? (We highly recommend you make a Personal Palette as explained in our book *Visual Chronicles: The No-Fear Guide to Creating Art Journals.*) Color can be opaque or sheer, slathered on or lightly brushed in visible strokes. You can streak one color through another, create spray-paint effects or drip ink like shots of vibrant emotion.

Images

An image, too, can be the center or an accent to your page. Like memories flickering through our mind, the images can be partial or whole, shaded or bright. You can repeat (or omit) part of an image for emphasis. Your image can be a photograph or even a drawing.

Texture

We like to use texture to show movement, age, noise, dirt and depth. Sanding, tearing pictures, making scratchy lines and using a mottled background, for example, convey emotions that pictures simply placed in borders cannot. As we will show you, you can easily create textures to mirror your feelings with stuff from your kitchen or garage.

Words

Even one word can be the focal point of your journal entry. Think of graffiti: A styled word tells a story bigger than its definition. Use a font or handwriting that captures the tone of the meaning you want to convey. Plan the size and color of the letters to suit your message.

Adhesives

How you attach images and elements to the page strongly affects your creation. Photos that are straight, cleanly cut and glued down convey a different feeling than photos with dimensional edges, affixed with masking tape and partially obstructed by paint.

SET UP CAMP

Grab some "scratch" paper and photos to play with. Let's set up our camp with easy ways to show how we feel and to say what we mean. With these techniques, we sisters are going back to our roots—straight outta Frisco (San Francisco, that is). In San Francisco, the streets and alleys are alive with an eclectic mix of graffiti, punk rockers, businesspeople, gangs, artists, children, mystics and surfers. The mix itself is art . . . as we all are.

SANDING

Sanding an image can convey different emotions, not just a "weathered" look. How you use the image in combination with text determines the meaning. A sanded image implies irritation, annoyance, a rough edge. Sanding also can mean longevity, endurance and a softening of the edges.

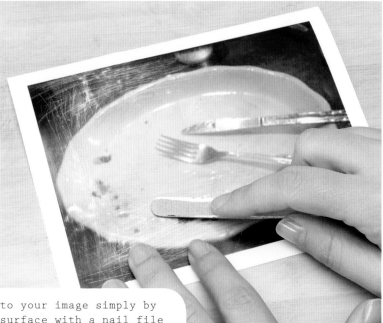

Add emotion to your image simply by sanding the surface with a nail file or sandpaper. Give yourself a little manicure when you're done.

SCRATCHY LINES

Scratches and scrapes of color imply movement and discord in your art. Thinner lines can suggest a shift, and thicker lines might be the quake of emotions colliding. You can use these lines to hint at static or surface noise. Jagged lines, with different amounts of space between them, also imply the transmission of ideas or images (think of Scotty, beaming up).

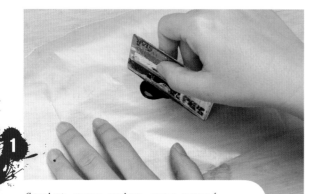

1 Squirt some paint onto waxed paper. Slide an old, expired, never-gonna-be-used-again credit card lightly through the paint.

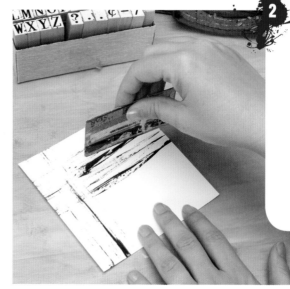

2 Drag the card edge along your paper, letting the paint transfer in a jagged line. You can repeat the process as many times as you like to make a few or several lines of different lengths.

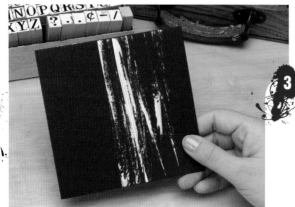

3 Try this effect with white paint on dark paper, too. The mood is totally different.

TEARING PAPER

Torn paper or photographs imply urgency, fragmentation and rebellion. Torn paper creates two edge styles at the tear: One side is white and appears bordered, and the other has a cleaner, jagged edge. You can pick which side suits your journal page. Even if you don't get it torn just right the first time, be sure to tear in the same direction you started with. If you "fix" it by tearing the other way, your edge will look different.

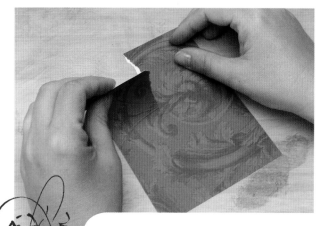

Place your paper on the table and hold down the part you want to tear around. With your left hand, tear the paper toward you, creating the white edge on the right side of the paper.

DISTRESSING WITH TAPE

Physically removing some of the layers of your background paper makes your art mimic your bare emotions. You can create backgrounds with raw edges or middles, mirroring your vulnerability and depth.

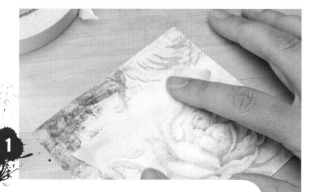

Put a strip of sticky masking tape on your paper. Burnish it down with your fingers.

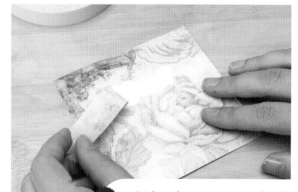

Lift the tape up slowly, removing the top layer of paper as well. If the darn tape won't come up, just use it as part of your page, and start over.

STAMPING WITH OBJECTS

Don't have any rubber stamps? No problem. Take the lid off that water bottle you are supposed to be drinking from every fifteen minutes and stamp with it! Use the heel of your shoe. Take a plastic fork from the kitchen at work. These abstract textures will create unique art!

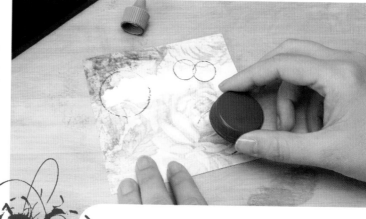

Press your "stamp" on the ink pad, then on the paper. Roll the stamp along the paper or slide it across the paper, if the stamp shape works for that.

FAUX SPRAY PAINT

Nothing says "rebellion" like a bit of spray paint! Let out your inner graffiti artist—in the daylight hours and the safety of your own home. It's easy to avoid the noxious fumes and suspicious glares that accompany spray paint. Just fake it!

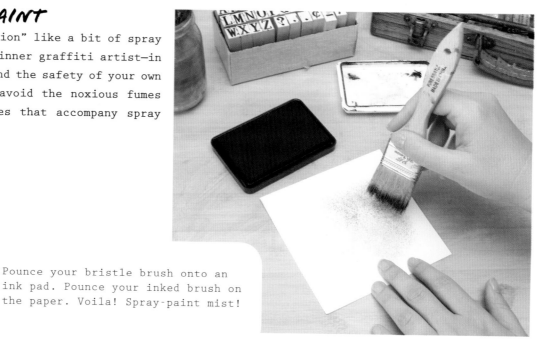

Pounce your bristle brush onto an ink pad. Pounce your inked brush on the paper. Voila! Spray-paint mist!

DRIPPY PAINT

Ever felt that time, emotions or life itself was beyond your control? Dripping paint captures the feeling of overflowing, overpowering, stuff-dripping-into-other-stuff. Bold spurts of color, dripping with emotion, can trickle down or up your page. You can also create lettering that is partially smeared or dripping to convey time passing or melding into other times.

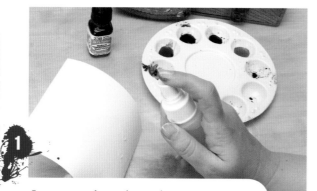

Spray cardstock or heavy paper with water. Your page will curl, but don't freak; it will flatten again.

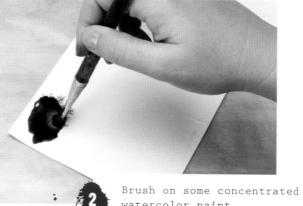

Brush on some concentrated watercolor paint.

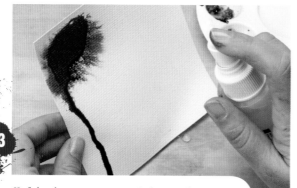

Hold the paper upright and spray it again so the paint starts to drip. You can tap the page against the table to help the drips flow.

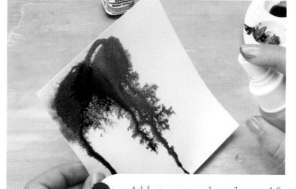

Add a second color, if you want. Spray it and let it drip down and into the first. It is OK if your colors blend, or if they don't.

TRANSMIT YOUR MESSAGE

It's not just what you say, it's how you say it. Your words can sing or they can pant, depending on the media you choose and how you place the words on your page. Just as we adjust voice inflection and volume when we speak, you can play with different volumes and inflections in your art! Tilt your words, make them drip, enlarge them or fade them. Remember: Communication, not perfection, is the goal.

TAPED TEXT BLOCKS

Let your words have their space! Create an urban look of bricks and art by blocking off areas while you "spray paint" and writing on them after the paint has dried. This looks like bricks on a spray-painted wall, highlighting your words.

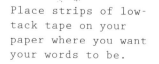
Place strips of low-tack tape on your paper where you want your words to be.

Pounce your bristle brush in ink, then pounce it on the paper around and on top of the tape.

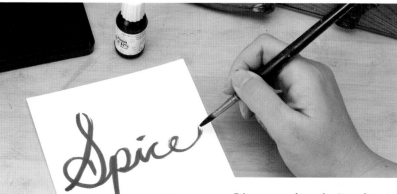

3 Peel off the tape to reveal the bricks where you can write your words.

WRITING IN INK

Create spontaneity, or a poetic mood, by writing with ink or concentrated watercolors. Just select a brush or other applicator (a cotton swab, or perhaps a feather) and try your hand at real handwriting. You needn't know calligraphy to write with ink.

Dip your brush in the ink. Get a lot of ink on the brush, unless you want your words to be invisible. Write your words on the paper. Go ahead and dip again, if needed.

STAMPING ONTO WET PAPER

If you want your words to appear misty and drippy, stamp them on moist paper with dye-based ink. Fuzzy words evoke feelings of yearning, sadness, nostalgia, head colds, the beach, rain, tears, history, cleansing.

1 Wet a piece of paper. Paint it with a basecoat of concentrated watercolor. While the paper is still wet, stamp letters onto it with dye-based ink.

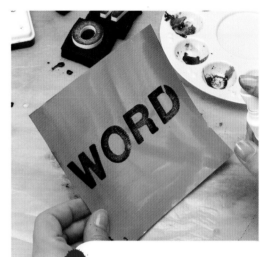

2 Spray the page with water so that the edges of the letters start to blur or smear. Set it aside to dry.

3 Randomly accent a few areas of the letters with a white correction pen, if you like.

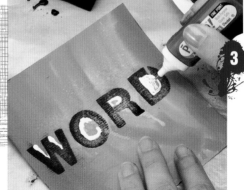

HAVE NO FEAR!

Use your trash—it's art, too. Look! The back of your paper has been sitting in pools of ink on your waxed paper, and it looks way cool.

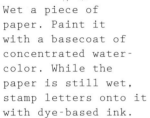

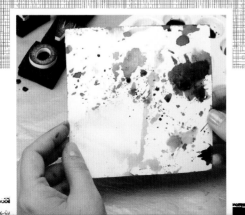

CLIPPED TEXT

There's a world of words out there for the clipping! Cut words from magazines, books, advertisements, past-due electric bills, e-mail or junk mail. You can also print out words and phrases you love, or hate, and use them in your art.

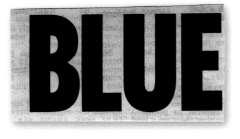

keep to the path

I know she meant it.

in a drop of dew

Don't worry if you can't cut in a straight line. Just find the right words and clip away. It is safest to own the book or magazine from which you are clipping. If you are a fast runner, go ahead and clip from other people's stuff.

HAVE NO FEAR!

There's a cheat code for lettering. If you want a certain lettered look, and don't want to cut it out, you can trace it. Just print the words from your computer on white paper. Turn the paper over, and with a soft pencil, scribble all over the backside of the paper, completely covering the back of the area where the words are printed.

Turn your paper back over. Place the paper right side up on your journal page, with the words where you would want them on the journal page.

Hold the printed page firmly on your journal page and trace the printed words with a ball-point pen, pushing against the journal page beneath. The graphite from the pencil drawn on the back of the paper will transfer to your journal page. You then can paint or ink over the pencil marks on your journal page. Erase any remaining pencil marks, if you want.

STAGE THREE
Crack the Code

Art breaks language barriers, allowing us to express feelings too big or too scary for words. By combining art with words, you can transmit messages on several levels at once. The background colors you choose hold meaning, as do the photos or textures. Likewise, with your writing, the slant and shape of the letters and the presence or absence of punctuation can match the force of your words. Your finished page may seem like an encoded secret, full of clues that only you and your sister understand. That's OK. Don't worry if nobody else "gets" why you chose purple or how you could possibly put an armadillo in the corner; your journal is for you.

By first "cracking your codes," you can quickly and easily create visual journals that match your deepest feelings. Mind you, deep feelings do not have to be about earth-shattering truths: We have deep feelings about pink-frosted party cookies, the scent of our beloved Nana and the back alleys of San Francisco's Chinatown. The important point is this: The colors and fonts we use when journaling about Nana are quite different than those we use to express the mystery and aromas of Chinatown. If we made a page about Nana using the fonts, colors and techniques suited to conveying Chinatown, we would be so annoyed with our finished page, we'd eat twenty pink-frosted party cookies. OK, OK. We were going to eat five anyway.

To crack your code, you need to know the meaning or emotion that different colors and fonts hold for you. Take a few minutes to reflect on the emotions you associate with various colors. With visual journaling, we combine colors and words, so the way you choose to write your words greatly impacts the overall impression. You can achieve many different looks by using just the fonts in your word-processing program. Begin by taking a look at the fonts you already have, and as you scroll through them, assign some feelings to each.

HAVE NO FEAR!

Decode your personal color schemes. Make a list of several colors, and next to each write an emotion (positive and negative) that color represents to you. Do the same for people and places important to you, asking yourself what colors represent them. Keep this list to inspire your color selections. You can even make your own Personal Palette, as we show you in *Visual Chronicles.*

FONTASTIC EXPRESSION

Here are some common fonts you can find in word-processing programs and the feelings or images they might conjure.

Alba Cute, artsy, creative

Arial Direct, unemotional, careful, clear

Bell MT Quiet, sad, simple, pure, honest

Comic Sans MS Youthful, humorous, friendly, warm

Courier New Definite, sad, reporting, bleak

Curlz MT Overused; don't ever use it

Dauphin Mystical, haunting, hushed, lyrical

EngrvrsOldEng Proper, antique, pedigreed

ERASERDUST Scrawled, hurried, harsh, rough, annoyed

Gill SansUltra Bold Mod, hip, wild, sixties

Harlow Solid Italic Neon, fifties, diners, fun

Jenkins Vz Crazy, scared, masculine, angry, hurried

Lucida Calligraphy Formal, musical, thankful

Mistral Windy, inky, deep thinking, reflective, thoughtful, speculative

Porky's Silly, unbalanced, childish, nervous

Rockwell Nostalgic, Americana, preachy

As you scroll through the fonts available on your computer, or available from free font sites on the Internet, you will see that a simple font choice has a huge impact on your message. Your journal page conveys one meaning with the words: *I saw him.* The meaning is very different with the words: I saw him. The first entry is referring to Prince Charming, the second, to Charles Manson.

Your choice of colors also impacts the mood of your writing. Red words mean something different from blue words. Faded, streaked letters, splattered with paint, transmit yet another meaning. Letters written with a brush dipped in vibrant ink, by your own hand, might capture feelings no font can match.

Let's take a look at how the right font and colors can help you convey exactly what you want. We have created three journal pages with only the font and color choices varied. As you look at each, notice what feelings the art evokes in you and how the particular lettering style contributes to that feeling.

Waited (Red Bazooka font)
This wacky red Bazooka font looks like something Bugs Bunny scrawled while waiting for the Road Runner. No, no, no.

Waited (Pink Barbie font)
The Barbie font used here is playful and giggly. Particularly in cheery pink, it conveys a sense of happiness and excitement, sorely at odds with the intended meaning of the words themselves. The shocking brightness hardly indicates disappointment, longing and time passing. Instead, the wording makes you want to sing "Happy Birthday!"

Waited (Black Lynch font)
Using Lynch font in black conveys bleak feelings, and the mottled texture matches the weathered look of the image itself. Letting your letters run off the page creates the sense of time slowly moving on, and of repetition.

You see the difference lettering can make! Especially when a word or two is the focus of your journal page, how you write that word is key. Wield your words intentionally and powerfully. Your art will speak more clearly and strongly, and you will not feel that something, somehow, is wrong with your page.

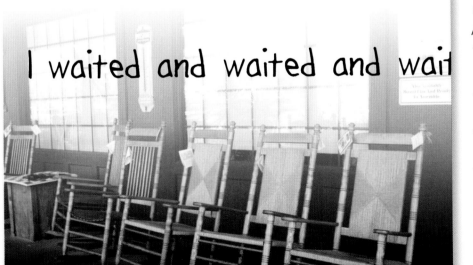

ABC ART*ILLERY*

Fill your art arsenal with the lettering and font styles that hit your emotions exactly on target. You probably feel inspired to paint and collage just by looking at the fonts in your word-processing program. You will be even more inspired once you create your own store of personalized fonts, already matched to the feeling, place or person each lettering style evokes in you. This card catalog of lettering styles is fast and fun to make and **will trigger memories**, insights and unique journal pages.

MESS KIT

blank Rolodex card
decorative paper
scissors
glue stick
Rolodex punch

rubber stamp
and ink pad
computer-
generated text
fine-point
permanent marker

1 Choose some decorative paper suited to the mood of your font. We chose circus-striped, groovy-looking paper, because this font reminds us of the groovin' sixties. Trim the paper to a Rolodex-sized card.

2 Attach the decorative paper to the Rolodex card with a glue stick.

3 With your handy-dandy Rolodex punch, punch a new set of holes through the decorative paper.

4 On the front of the card, stamp images that match the mood of your font. We used flower-child, groovy images.

5 We used our chosen font to type the feeling that font evokes in us: fee-lin' groovy. We cut out the words and attached them to the front of the card with a glue stick.

6 Embellish the card with black-and-white pens. Write the name of the font on the back of your card for easy reference.

HAVE NO FEAR!

Create your own booklet of daily affirmations, inspiration and guidance, based on the truths you have uncovered for yourself. Speak in your own language and use unique images that inspire you.

Inky in a scary movie kind of way

Scary Movie

We love Chiller font. Looking at it, we can feel the undead sneaking up on us. When we want that inky in-a-scary-movie-kinda-way look, Chiller is the choice. The drips of red paint and crackle texture (rubber stamps) add to the scary movie feeling on this card, and the black ink rubbed on the edges of the card feels shadowy . . . like a graveyard. We outlined the card with a metallic permanent pen.

Pensive

Don't forget that your own handwriting has many styles! This is Linda's pensive style. Linda is a very thoughtful person, often caught in pensive moods. She could be thinking: Why can't men eat crackers for dinner? She might be wondering: Why, oh why, is Ashton Kutcher famous? Using your own handwriting conveys you in your pensive moments. Linda highlighted this card with blue, her thoughtful color. She outlined the card with a metallic permanent pen.

THIS IS WHAT MY PENSIVE MOOD LOOKS LIKE

Hip

Add photos and doodling to your cards, too, to capture the mood of the font. Treason font feels hip and edgy, as if it is trekking through the city, wearin' black and lookin' baaaad. The taxi zone image and the yellow dashed lines convey the feeling of walking through a city. By pressing an ink pad lightly on the card, you can make geometric shapes that suggest buildings, and rubbing ink on the edges of the card creates the grungy look of the streets. We outlined the card with a metallic permanent pen.

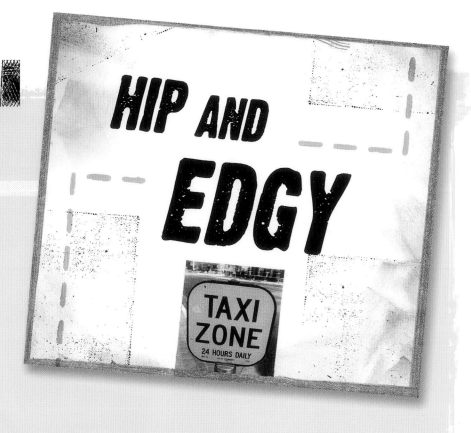

HIP AND EDGY

TAXI ZONE
24 HOURS DAILY

Romantic

Flowers, music, pinks, reds . . . this card presents images of love and romance. Edwardian Script is oh-so romantic. Who could say anything mean in Edwardian Script? The images are just punched from decorative paper, and the lovely scroll (like a garden gate) is the top of a rubber stamp. With stamps, you can always use just the edges of the image, or the middle, if you like. We outlined the card with a metallic permanent pen.

oh-so romantic

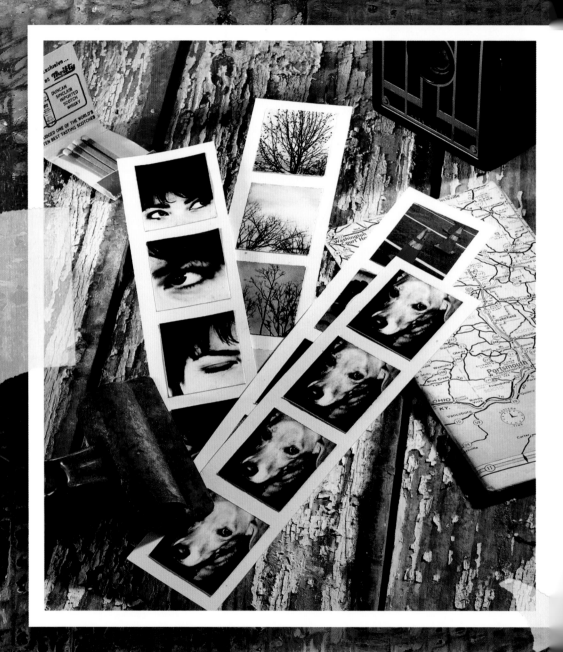

STAGE FOUR

Covert Operations

In times of revolution, some thoughts feel too dangerous to say outright. We may need to present our emotions symbolically, because we know no other way. Sometimes, we want our journal pages to rant loudly to many, while secretly whispering in code to a few. Our journals and loose pages call to us: Spill your secrets, speak your truth and create your freedom.

"Art journaling" too often is synonymous with "layer on paint, papers and ephemera." We love layering . . . and we have come to see the beauty when we remove the layers, bring out the simple truths, laugh at ourselves and let the tears be wet. Our inner Central Intelligence Agencies have been hard at work for decades, gathering data and images. We have piled stuff on top of some of our best finds! In some cases, we have buried treasures and legends. Our journal pages are the safe places to share our secrets, store our mind's snapshots and download the hidden data that run our lives.

We've actually discovered the source of some of our own odd habits just by stopping for a few minutes to journal about them. Of course, we could have just asked each other why Karen must have the aisle seat, or why Linda avoids birthday parties. Either way, creating art about why we are who we are is liberating. If there is a stranger lurking, let her not be within. Visiting, knowing and expressing every part of ourselves is smart.

Let's tell our secrets, share the images that tickle and haunt us and let loose with the sound reels that repeat in our minds. Opening up your covert operations doesn't have to scare or hurt anyone (you, most importantly!). Your journals can speak briefly, symbolically and without judgment, if you want. We have been known to judge every once in a while, but we try to judge only the edible or the dead. You can also accuse, blame, applaud and curse. We can't curse, because this is a family book. Remember, you do not have to show your journal pages to anyone. What art would you make, if no one were looking?

HAVE NO FEAR!

Play with your inner child. What secrets did she keep on the school yard? What picture from your old neighborhood is stuck in your mind? Can you hear a song your gang of friends used to sing as you walked through the forbidden forest? Journal it!

TRUTH BE TOLD

→ → →

Pretend the Freedom of Information Act has been initiated in you. You are free to speak your mind, to let out the truths from years ago, yesterday and today. Not only are you free to do so, you are demanding that you do so. Shed the weight of self-deception; discard tattered and worn blankets that never protected you anyway.

On your journaled surfaces, you can testify to your truths without fear of cross-examination or backlash. Do not be intimidated by the journal book or by someone reading it—you do not even need a "journal" to "do" journaling. FORGET about the darn journal. Just express yourself in an artful way. Do it on a napkin, a sticky note, in a magazine or book, on a grocery bag, on toilet paper (hey, our brother did!), on a huge canvas, with just a scribble on a receipt. It does not matter what you express on or with. You can write some words and put them in a safe spot or cut out an image and paint a bit on it. Whatever feels right for the moment or your purpose. If any notion of a rigid format is stifling you, purge that notion from your mind. You can put your expressive art bits into a journal later if you want, or keep them in an enticing journal box forever... or leave them at the bottom of a crammed drawer, to rediscover when you move. The expression is what really matters.

As you work with the techniques in this book, feel what memories and emotions they conjure. If you play around with paint or ink, you will find the need to speak your truth. You are tapping into parts of you that are eager to take the stand and shout. Pay attention to the thoughts that pop into your mind as you are driving or showering. Feelings seem to rise when we let our minds rest for a moment. So, keep pen and paper handy in the car and the bathroom. When you are talking with people, listen to what you want to say. Listen in on what other people are saying and to what you thought they might say to you. Since text messaging is so common these days, no one will think it odd when you whip out your PDA to make journaling notes while they are talking. It helps to wave your hand grandly while saying, in a vaguely British accent, "Carry on, carry on."

Capture life while it is happening. Life is not just the present moment; it is a mix of what physically is occurring right now, with the images in your mind, and the emotions evoked by the mix of the two. Your art may look a bit surreal when you depict this mélange, and that is just how it should be.

SPY ON YOURSELF

→ → →

Secrets are passing all around you, and you are at the center of many. Put on a trench coat and some cool shades and spy on yourself for a few days. If you want, try wearing some disguises, so you don't recognize yourself and clam up. Pretend to be sleeping. Act as if you are just grocery shopping or treadmilling while singing Neil Diamond's latest remix. You can then pass completely unnoticed, as you conduct your surveillance mission. Rifle through your old photos when no one is looking. Indulge in some good old-fashioned melodrama (for a maximum of ten minutes at a time) to uncover buried secrets. Here are a few more stones you may want to turn.

* Pull out those old yearbooks: Who were you through your school years? Who did you pretend to be? What did people write to and about you? What did you really think of them and yourself? Who or what changed you?
* Recall your dreams: Who is in them? Where do you go? What dream repeats through the years?
* What lie do you keep telling, despite yourself?
* Look at your "My eBay" page: What are you bidding on? What are you obsessively collecting? Who are you stalking?
* What is in your TiVo Season Pass list? Are you secretly addicted to soap operas or late night talk shows? Can you quote every *Happy Days* episode?
* What is the last thing you really, really laughed at? What has recently saddened you? What makes you so mad, you'd give up everything on your TiVo and eBay lists forever if you thought it would change things?
* How many *NSYNC songs are really on your MP3 player?
* What wouldn't you clean, if no one would know?
* What would you confess, if your salvation depended on it?

These secrets, and many others, are just beneath your surface. You can laugh at them, cry with them and, ultimately, accept them by making art of them.

I DON'T HUG PEOPLE

BECAUSE I AM AFRAID

THEY WON'T

LET GO

MESS KIT

photo	scissors
nail file	double-sided tape
permanent ink pen	ink
white paper	stamp

Keeping secrets got a bad rap somewhere around first grade, when whispering and giggling were forbidden, and we were shamed into telling all or forever shutting down. There is a time and a place for secrets: now, on your journal pages. In our journal pages, we can **combine voyeurism with self-expression**—we love to see what others are hiding and to come out of the shadows ourselves. By keeping your secrets as art, you honor them and give them a respected home. Lovingly let them go and accept them in their new form, as **an artful expression of you.**

You can share your secrets if you want; you will no doubt find others with the same secrets, or people eager to laugh and learn with you as you unravel yours.

Hug

Some people are "huggy." I am not so huggy, and I know that this troubles huggy people. This journal page reveals my secret fear. The scratched lines simulate discomfort, poor connection and distance, and the handwriting communicates tension.

Create that staticky, secretive, you-can't-see-me-clearly look by sanding a photo with a nail file.

2

To give a personal feel to the page, I wrote my secret by hand. You could use a handwriting font, too.

3

Cut out your words in strips. Don't worry if the white space around your words is all even or uniform. The variation helps create the tone of your art.

4

I used double-sided tape to adhere the words to the photo. For these strips of paper, double-sided tape can be easier and less messy to use than glue stick. Place the words unevenly, because your thoughts pour out of you that way.

5

Embellish the page with a stamp that matches your mood. This off-center target was perfect.

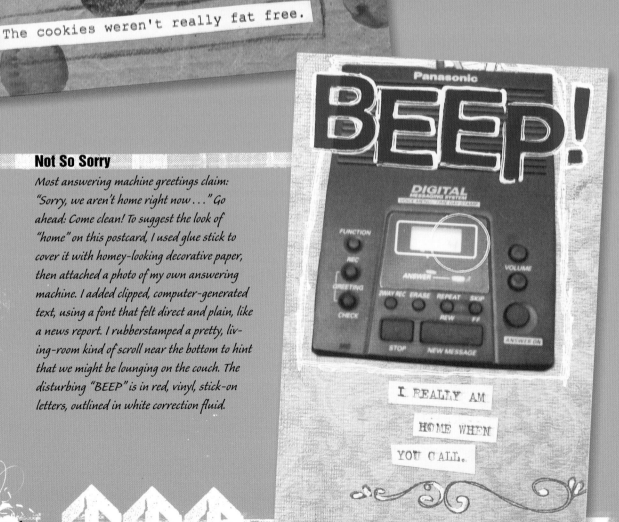

The cookies weren't really fat free.

Sweet Secret

If only they made fat-free, pink-frosted party cookies. Well . . . some people think they do. Some people think we bake them. For this revealing page, I used glue stick to cover a post-card with paper cut from a grocery bag. Then I added a photo of the cookies, glued on my text and rubber-stamped circles to mimic the cookie sprinkles. I outlined the text in pencil.

Not So Sorry

Most answering machine greetings claim: "Sorry, we aren't home right now . . ." Go ahead: Come clean! To suggest the look of "home" on this postcard, I used glue stick to cover it with homey-looking decorative paper, then attached a photo of my own answering machine. I added clipped, computer-generated text, using a font that felt direct and plain, like a news report. I rubberstamped a pretty, liv-ing-room kind of scroll near the bottom to hint that we might be lounging on the couch. The disturbing "BEEP" is in red, vinyl, stick-on letters, outlined in white correction fluid.

I REALLY AM HOME WHEN YOU CALL.

Scary Balloons

They are on the ceiling now, but who knows where those balloons will be in a second, or if they will *POP* in your face when you least expect it? My own shaky handwriting is perfect for these freaky balloons, huddled together, waiting to torment people. I glued a photo of balloons onto a postcard, then added faux spray-paint haze.

I am afraid of balloons.

I still sleep with the blanket she made for me.

Made Especially for You
Nana

Secure Nights

When I was born, my Nana knit me the best blanket ever. It holds her love and wisdom in every stitch. When I was thirteen and still sleeping with it, I remember she asked me, "Are you going to sleep with that blanket when you are married?!" Without hesitation, I replied, "If I have to choose between my husband and my blanket, my husband is going!" For this simple secret, I covered a postcard with a photo of my baby blanket and handwrote my secret.

HAVE NO FEAR!

What are you afraid of? You will take power and anxiety from what you fear by journaling about it. Give your fears their colors, find their perfect fonts and exorcise your secret fears through art. You can do corresponding journal pages proclaiming your courageous victories over your fears.

I AM ART **I AM ART**

GOING UNDERCOVER

Instant cameras allow us to glimpse reality in an instant. The glimpse often is blurry and shadowed, and the color can be a bit off, but so is life. As you go undercover and stake out you, our Fauxlaroid is **the perfect way to depict you**, unaware and unposed. These faux instant-camera images can be made from any new or old photo, a letter or e-mail, book or magazine clippings or even fabric. Using Fauxlaroids suggests nostalgia and gritty realism. Make a Fauxlaroid and grab a moment of you.

MESS KIT

white cardstock	double-sided tape
pencil	fine-point
cutting mat	permanent marker
ruler	
craft knife	
photo	

1 Cut a piece of cardstock to 8½" × 3½" (22cm × 9cm) and fold it in half. On one half, rule a 3" (8cm) square that is ¼" (6mm) from the sides and fold, and 1¼" (3cm) from the bottom.

2 Trim the window out, using a craft knife. This will be the top of your Fauxlaroid. Fold the card in half so that the window is on top.

3

Apply double-sided tape to the back of the photo and stick it inside the Fauxlaroid in the middle of the area that will show through the window.

4

Put double-sided tape on the back side of the window, so that you can fold the card closed, and it will stick together.

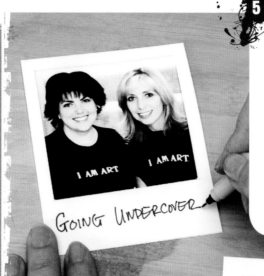

5

GOING UNDERCOVER

You can journal on the bottom of the Fauxlaroid, using handwriting or clipped text. If you are going to use the Fauxlaroid on a journal page, you may not want to write on the bottom, because you might collage across part of it or have the journaling be partially on the Fauxlaroid and partially on your background page.

Plump

This Fauxlaroid literally pushes the limits of traditional instant photos, because the image breaks out of the photo emulsion boundary. I extended this image with paint to achieve a strong feeling of "plumpness." Go ahead and push limits. Be plump.

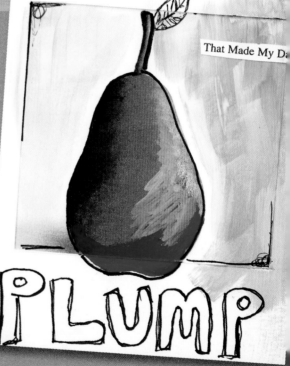

That Made My Da[y]

PLUMP

HAVE NO FEAR!

If you feel self-conscious about seeing yourself in your journal or have some fear that you'll look all double-chinny in group photos, select what part of you should be in your Fauxlaroid. You can crop and zoom close up on your lovely hands, your mesmerizing eyes, or your rosebud lips. Be in your own art!

Favorite Jacket

I loved this Chico's jacket, and I wore it . . . well, nearly every day. When it got stained, I wanted to pay tribute to it. I cut some fabric from the jacket and saved a button to create a Fauxlaroid. I used a pen and my own handwriting to write, "Now I have nothing to wear."

now i have nothing to wear

Look Up!

This Fauxlaroid from Pasadena, California, captures the wonderful mix of colors and elements that can coexist in a city. Looking up, I saw cool geometric shapes and—surprise!—beautiful flowers. I emphasized the flowers by painting on the Fauxlaroid and used permanent ink pen to write my caption.

LOOK UP! HE SAID. I DID.

Monks in Our Midst

As in life, sometimes the most interesting thing in a photo happens in the background. We went to Starbucks one morning, and sitting right behind Karen was a Buddhist monk. This great omen began a great day. I simply typed my journaling, cut it out in strips and glued it on.

our daily walk to
starbucks was a
spiritual experience.

we found the boat and
snuck our way on

HURRAY!

Hurray

Let your Fauxlaroids tell a story. When our friend Tonia finally found this boat, it had every ounce of the character she had hoped for. I used her picture as the base for the Fauxlaroid, then used a typewriter-style font for the clipped text, creating the feel that these lines are cut from a longer letter. I glued the lines on the photo and stamped HURRAY! at the bottom.

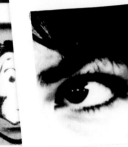

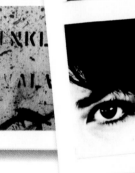

FAUXTO
BOOTH STRIP

Don't throw out those frizzy-haired, blinky pictures of yourself! Fauxto Booth 'em! In photo booths, we make silly faces, pose with rarely seen friends, jumble too many people together and wind up with strips of unexpected pictures. Like photo strips, Fauxto Booth strips can **show a fragment of you**, repeated shots of the same image or four different views. When we create our own faux strips, we aren't limited to things that might squeeze into that booth. We can use trees, street signs, restaurant tables, ancestors . . . whatever we want. Because these are "fake," we can be sneaky with what we show; we can use Fauxto Booth strips to pretend we were somewhere or with someone. Or we can use them to **snap candid photos from our deepest destinations.**

➡️ **MESS KIT**

photos
ruler
scissors
white cardstock
pencil
glue stick

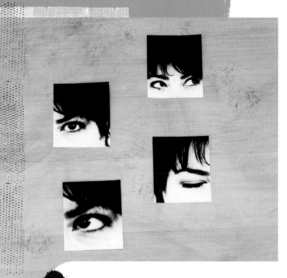

1 Trim four coordinating photos to 1¼" × 1½" (3cm × 4cm) These can be either vertical or horizontal.

HAVE NO FEAR!

Make a Fauxto Booth strip, and then scan or photocopy it for use in your journals more than once. Cool creations and great pictures—even just great parts of a picture—should not be limited to one-time use. There is repetition in life, and life imitates art, eh?

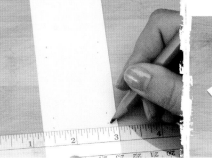

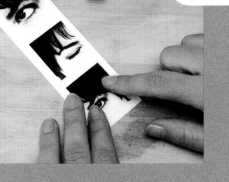

3

Glue the photos to the strip, using your marks as a guide. Erase your marks when you are done. You can now use the Fauxto Booth strip in your art!

2

Trim a piece of cardstock to the size of a photo booth strip: 1¾" x 7¼" (5cm × 19cm). Your photos will be placed on this strip, with a ¼" (6mm) border on all sides of each photo. So, mark off lines in pencil to show you where to place the photos. In our sample, the first photo is placed ¼" (6mm) below the edge, so the second photo is 2" (5cm) below the top edge (¼" [6mm] below the first photo, which is 1½" [4cm] tall).

Seasons

This Fauxto Booth strip shows the stark beauty of winter, with images of cold trees and chilly skies. By varying the images, I create the feel of an old movie, flickering before your eyes. I love the feeling that I am still standing in the park, twirling, looking up at the trees and sky.

Shelby

Your pets make excellent Fauxto Booth subjects. Shelby's soulful eyes are magnified by repeated expression, and the strip accentuates that she is a constant companion in our friend's day.

Streets of San Francisco

These are all images from a day walking through San Francisco. I can't fit in a real photo booth with these essential SF reminders, but in my journal, there are no limitations.

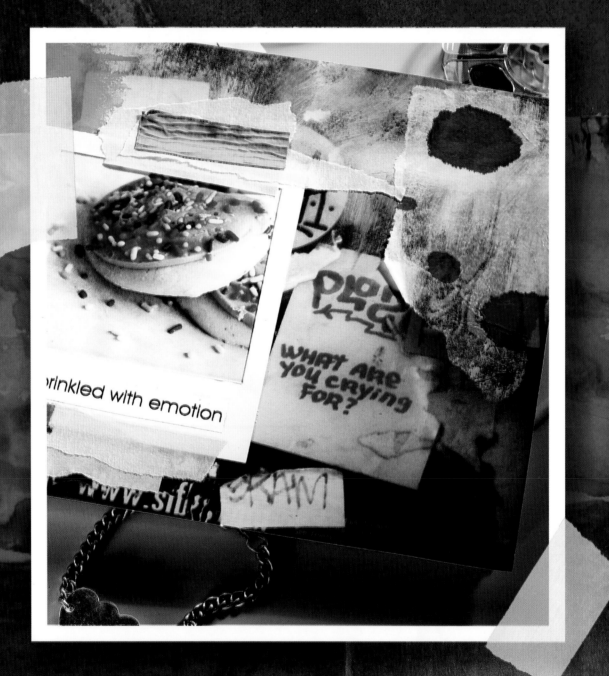

STAGE FIVE

Expand Your Borders

When we think of journaling, what often comes to mind are someone else's stacks of tightly bound leather journals, carefully dated and cataloged by season or excursion. These journals invariably overflow with detailed descriptions of flora and fauna and vivid, lifelike drawings of gentlemen in caps playing chess by a fountain. Typically, they are peppered with French or Latin expressions. These journals scare us and make us afraid to start, for fear of having to pretend a life, travels and patience we may never have. School journals are another breed. In them, we were required to diagram sentences or write about why children left alone on islands always behave so badly. If we were lucky, in art class, our teacher might have tried scrapbooking. But the "journaling" taught there was more like letter writing to strangers, done to be read, not to be real.

Let's expand our borders. Give us artistic liberty or give us artistic death! There's a way to journal that comes naturally, when you just let words escape you. Forget whatever old notions of journaling are scaring you or repulsing you and broaden your view of what journaling can be. Journaling is expressing yourself. Period. No other rules, no other requirements. There are no mistakes in journaling, or in art. With art journaling, you are just transferring the art that is you to some surface. You do not have to use a book, or even paper. You do not have to write about a vacation, your family or literature. No one is going to edit your journal for proper grammar and spelling or challenge your memories.

Expand what you usually journal about and the way you usually express yourself. To begin, try looking around your city—really looking around. Look at the train station, bus stops, trash dumpsters, sewer grates, jazz clubs, parks and little cafes. Try to see the beauty in each—and the art. Notice the graffiti scrawled by the train tracks (take a picture of it!). Pick up grocery lists and apology notes you find fluttering in the wind. You may be surprised at the pieces of you that are represented in each and every neighborhood you pass.

Look, too, at your inner neighborhoods. Venture into your darkened corners with your camera and flash ready. Document who is living there. Interview parts of you that rarely come out to play and journal their words. Laugh over cookies with your best friend—you.

CROSS THE MINEFIELD →→→

Step outside your comfort zone and you might set off hidden explosives. Joy, anger, sadness, love, exhaustion, resentment . . . each of these may erupt in front of you as you tour your inner landscape. These bursts of emotion and insight make vivid art journal pages. Your mood swings, outbursts and introspection can coexist in intensely personal, journaled art.

You can use the techniques in Stage Two (see page 10) to convey the fierce energy or chilling emptiness you sometimes feel. Choose background colors or images that evoke the intensity of the emotion you are expressing. For example, your favorite color might be vibrant red. But if you are journaling about your deep sadness, using vibrant red will probably send a different message. You will wonder why no one gets teary-eyed when looking at your heartfelt, red page. Now, if you want to journal about your frustration that no one cried over your red page, *then* you can use red. Red suggests anger, frustration and heat; it clashes with feelings of loss, coldness and sad tears.

Using the city as a metaphor for yourself can help you choose colors and styles. Downtown is vibrant, loud, black, yellow, red, blue, gray. Graffiti looms large, with uneven letters and unexpected flourishes. Wet paint shows up where you least expect it. Trash overflows into flower pots, and yellow taxis blur against street vendors. It takes guts, sometimes, to walk alone downtown. Take those same guts and journal your inner city. Use drippy paint, scratched lines, black and jagged edges. Resist the temptation to make it pink and pretty. Tell it like it is, and see how *that* is pretty.

HAVE NO FEAR!

Pick a line from a favorite song—one that targets your emotions exactly—and journal with it. Practice creating the right mood with bolder colors, contrasting patterns, inky styles, dripping paint or homemade stamps.
You can quickly make a journal page with the words *BOTH SIDES WERE AGAINST ME SINCE THE DAY I WAS BORN.* Maudlin, yes, but fun and real to journal. If you know what song that is, go get yourself some chocolate chips as a reward!

SOUND OFF:

LET WORDS ESCAPE YOU

When you are journaling about your inner world, think: *EXHIBITION, not "narration."* Grab your thoughts mid-sentence and throw them on your page. Imagine that someone has found clips from a surveillance video of your life, and you are taking sound bites here and there to make journal pages. You might capture only one word or the same word repeated again and again. You might get the middle of a story. Perhaps you will hear an apology, a groan or a prayer.

Spontaneous expression feels authentic and conveys your personality. With your visual journal, you are not writing a letter or a book. You do not have to address your comments to anyone or explain anything. If you write in the second or third person, or explain every detail, your journaling will sound more forced and generic. Compare these two examples, each accompanying a photo of a knit blanket:

✳ Nana, you made this blanket so lovingly for me. Your hard work is in every stitch. I love watching you be a wonderful grandmother.

✳ I still sleep with the blanket she made me.

SOME DAYS I SPEND HALF THE TIME JUST WONDERING WHAT THE HELL I AM DOING AND WHEN I WILL BE DONE

WHA

What

This stream-of-consciousness journal page says more about me than probably could be said in a whole, traditional photo album. I sketched a self-portrait in pencil, erased and re-sketched a few times, then went over my lines with a permanent pen. I randomly painted in my image and background with concentrated watercolor paint, using colors that matched my mood. I added some doodles and outlining with correction fluid pen. I handwrote my journaling with a permanent maker and rubber-stamped the question mark and large WHAT.

The second example expresses, simply, everything that is in the first—more like someone's shared thought, as if we were listening in on her stream-of-consciousness words. Look at how quickly you convery a lot when you text- or instant-message your friends with few words and meaningful abbreviations. Try using that style in your journaling. Practice letting words escape you and don't edit yourself. Speak your mind and heart. Then, put that in your journal.

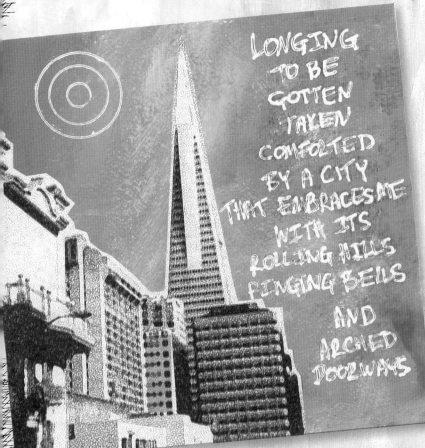

LONGING TO BE GOTTEN TAKEN COMFORTED BY A CITY THAT EMBRACES ME WITH ITS ROLLING HILLS RINGING BELLS AND ARCHED DOORWAYS

Longing

One day, I was so wishing to escape where I was and be in the city by the Baa-aay. I basepainted watercolor paper with acrylic paint in orange and yellow, to convey the aching and burning feelings. I used a glue stick to attach a cut-out, color-copied photo of San Francisco. I added a touch of blue paint to the photo, for the blue skies of the city. I doodled some circles at the top and handwrote my journaling with a correction fluid pen.

WHISPER

give me a whisper words just for me that nobody will take or ruin or ~~use~~ use against me my own little happy thing

Whisper

Sometimes secrets are special and whispers create unbreakable bonds. For this page, I first stamped WHISPER onto wet, thin, white paper, using the stamping onto wet paper technique. While that dried, I painted a piece of watercolor paper creamy yellow and white, then added dripping paint to it with gray, concentrated watercolor. I attached the WHISPER with glue stick to the watercolor paper. I handwrote my journaling in permanent pen, added rubber-stamped circles and attached my Fauxto strip with first-aid tape. I added a few scratches and doodling accents to the page.

Lost and Found

Whenever I look at the Golden Gate Bridge, I am mesmerized by the deep plunges of the suspension bridge cables. They remind me of the up-and-down, lost-and-found patterns in life. This journal page blends the feelings of lost and found. The background is a grid, printed on cardstock. I enlarged a photo of the bridge on a color copier and cut it out along the top edge. I tore the bottom to look like water at the edge of the beach. I glued down the bridge, then added faux spray-paint haze and a few drips to the page. I handwrote my journaling with a permanent pen. I rubber-stamped the ampersand and used vinyl sticker letters for LOST and FOUND.

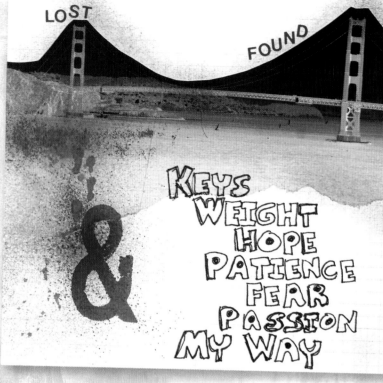

LOST
FOUND

KEYS
WEIGHT
HOPE
PATIENCE
FEAR
PASSION
MY WAY
&

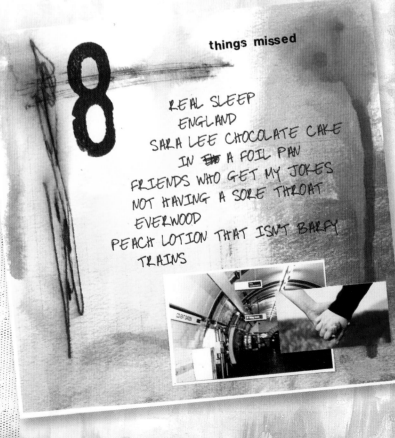

8 things missed

8
REAL SLEEP
ENGLAND
SARA LEE CHOCOLATE CAKE
IN ~~EID~~ A FOIL PAN
FRIENDS WHO GET MY JOKES
NOT HAVING A SORE THROAT
EVERWOOD
PEACH LOTION THAT ISN'T BARFY
TRAINS

8 Things Missed

When I made this page, I was feeling as if so many things I longed for weren't around anymore. I felt in the midst of loss. I listed the things and people I was missing and used colors, textures and images that conveyed my feelings. First, I painted a piece of grid-printed cardstock, using the drippy paint method. I then experimented by adding some black paint scratches over the wet paint. The blurry, teary look is just how I felt. I handwrote my journaling in permanent pen, rubberstamped the big 8 and added vinyl, stick-on lettering. I glued on my photos. Yeah, I was sad, but don't cry for me. I cheered right up after I saw how cool my art turned out!

SOUND OFF:
HEAL YOUR WOUNDS

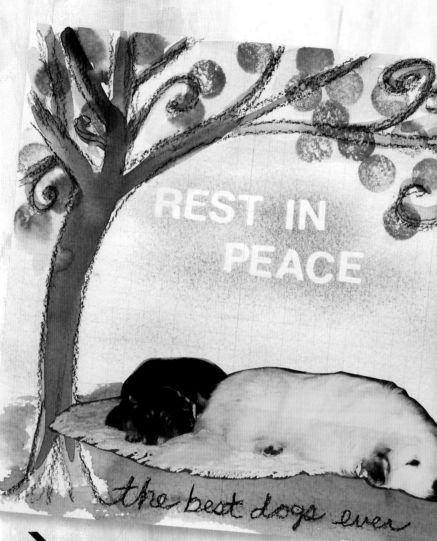

As you begin "sounding off," letting your opinions and feelings flow, you may discover places of loss or wounds. Art journaling helps us heal our wounds by answering their calls and giving them a voice. You might express your longing for lost friends or a lost pair of favorite jeans. Try this: When you are feeling a strong emotion, sit down and write every thought, color, adjective, image, person or action that comes into your mind. Your thoughts might seem random, but write them anyway. A sadness passage might look like this:

Choked, tight, blue, shiver, floating, white, gray, shrink, Pioneer Park, burning, soft, lost, reaching, clinging, sweet eyes, hugs, warmth, best dogs ever

After writing your free-form list, pick what words and images you can use for your journaling. You can do the same with any emotion. Look over your chosen words and select a font from your ABC ARTillery (see page 26) that conveys your emotions perfectly. Your own handwriting may be the perfect fit.

Rest in Peace
We miss Sam and Mandy, the Best Dogs Ever. True, they also could be called the sheddiest and drooliest and misbehavingest dogs ever...but they gave the best hugs and love, and they still visit us in our dreams. On grid-printed cardstock, I loosely sketched a big tree with pencil. I painted the tree trunk, branches and grass with concentrated watercolors. I cut out the image of our dogs from a color copy and attached it with glue stick. The sky is a blue, faux spray-paint haze. For the lettering, I wrote REST IN PEACE with alphabet stickers, pounced ink on top of them, then removed the stickers. I handwrote my journaling in pencil, then rubber-stamped green circles for tree leaves.

We'd sit here watching the water trickle down.

Each drop carried our hopes and dreams to a safer,

calmer place.

Twenty years later, they came flooding home.

Trickling Back

When we visited our childhood house recently, we both stopped to gaze at this sewer. As kids, we all had sat on the curb beside it many times, thinking through problems and making dandelion wishes. This sewer grate has simple beauty and power for us, which I wanted to capture in this journal page. First, I randomly painted cardstock with blue concentrated watercolor. Then, I just attached the photo and clipped computer-generated text with glue stick. For the three dots, I dipped the eraser end of my pencil in the concentrated watercolor and stamped. The positioning of the text looks like water trickling, and the page has the feeling of movement, like the water and flooding feelings.

I Cried

We'd tell you what this page is about, but we'd just start crying again. Instead, I'll just show heartbreak in colors and textures. Here, I enlarged a photo on a copy machine and tore out the portion I wanted. I glued the image to lined paper, then added faux spray-paint haze with text blocks where I would later write my thoughts. I made scratches with blue paint. I handwrote my journaling in the blocks with a nonpermanent marker, then sprayed the page lightly with water so that my words would shake and tear, as I had. When the page was dry, I added the newspaper text with glue stick.

HEARTBREAK

I cried in my bed
I cried on the couch
I cried at breakfast
I cried in the car
I cried in the parking lot
I cried at the ticket counter
I cried on the airplane
I cried when I got HOME
I am still crying

COME OUT OF HIDING

→ → →

Now that you have let words escape you, peeled back layers to release and heal your wounds, you will find your last great border easy to leap. Expose yourself. You without a fake smile, a nice dress, a firm handshake, a kind voice for people you have to be nice to. Present the you your parents don't know (assuming you still speak to them). Take a close-up photo of your id, as Freud would call it, and then proclaim it goo-ood!

You are bound to realize truths about yourself as you travel through your inner neighborhoods. You will meet some parts of you that previously were absent in your art or journals. With your new awareness, you can journal from a deeper place with a different palette. The cool pastels, sepia tones or Victorian backgrounds you used to adore may not convey the strong, undiluted emotions now pouring from you. Reach for primary colors, bold shades that attract attention and the shadowy colors of cars driving through a city at night. As you create these pages, you won't look to others' art and ask yourself, "How can I make mine look like hers?" You'll close your eyes and ask yourself, "How can I make mine real?"

Making it real is easier than making it a copy. Feel your way. (Extra chocolate chips if you know what song that line is from, too.) Keep your ABC ARTillery handy, so your words speak from the page. When that word is heavy and stirring, let it sit alone on your page or canvas, staring out at anyone who gazes back. Use the kitschy, nostalgic look of Fauxlaroids to represent idealized versions of you or glimpses of your past. Fauxto Booth strips are perfect for returning wishes, recurring nightmares or anything you want to emphasize.

As we come out from behind our walls of defense, not only can we read the graffiti we have painted on them, we can create art from the crumbling bricks. Sometimes there is anger behind our tears, and other times, we can laugh in disbelief that we ever cried.

HAVE NO FEAR!

Play with your techniques. Spray water on your written words and see how you like the look as they smudge. Stamp over wet paint and experiment with ink blending into acrylic. Shred your photo and glue it on in strips. Write on tape or put semitransparent tape over elements on your page. Stamp on a photo. Scrape or bleach some emulsion off a photo. What's the worst thing that could happen?

READY OR NOT...

→ → →

Linda once found a really, really good hiding place in our kitchen, and none of us could find her. We called "Ollie ollie oxen free!" and still, no Linda. When it was time to watch *Emergency!* on TV, we gave up, and Linda eventually came out. But we never did know where she hid. She explained that if she came out, others would know her hiding place, and she could never safely hide there again. So, she preferred to stay hidden a long time, then she could always have her hiding place if she needed it.

Most of us have a favorite hiding place like that inside ourselves. We might hide behind a certain tone of voice, an illness, a habit of saying "yes" to everything, a wound, a job or other obligations. People may offer to let us come free, but we prefer the safety of having our hiding place.

Karen always just hated playing hide-and-seek—she'd get all nervous as soon as the seeker said, "Ready or not; here I come!" She'd think, *What if I am not ready? How come I don't get to be ready? Obviously, she knows I might not be ready, and she doesn't even care! Who wants to be found by someone like that?* Yet, as Karen learned, not being ready is just another way to hide.

If you think you don't know where to find the "real" you, peek in your hiding place. Ask yourself why you keep it and why you do not want to tell anyone where it is. Explore what you fear would happen if you ran out when they shouted, "Ollie ollie oxen free!" Who would be there? Who is trying to find you? (If you are Rosie O'Donnell, don't be scared: It's only us stalking you, and we just wanted to paint with you.)

Come out and play. Make journal pages that show you, in your life, or even in your hiding place(s). If you feel the inner you is a swirling, confused mess sometimes, then paint a swirly, confused self-portrait. When it seems like your days are dripping one into the other, drip your paint colors one into the other. If there is a part of nature that perfectly represents you, put nature in your journal and write of your unity. Ready or not, life is here. May as well live it.

SOUND OFF:
ME—UNDECORATED

Remove the glitter, makeup, cover stick and walls, and show yourself. Let us see you; it will help us to know ourselves, too. It's OK, really. You will be so very beautiful.

Decorate a page with the undecorated you. It's a funny concept. Sometimes the undecorated you is only one or two colors; other times, your hidden feelings are so vibrant, you can hardly believe no one saw them before. Don't be surprised if, once you start listening to your undecorated thoughts and feelings, it is nearly impossible to turn them off.

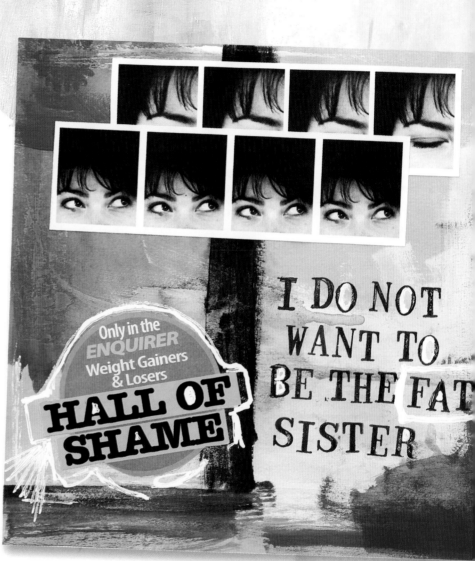

Shame

We have both been on diets for most of our lives, and take turns being the one who is thinking *I DO NOT WANT TO BE THE FAT SISTER*. Karen claims she has it worse, because she will always be "the flat sister!" Expressing my inner critic helps me silence her and accept myself as I am. For this venting, I randomly (freestyle!) painted cardstock in a mix of colors and shapes. When that paint was dry, I added the drippy paint technique, using gray concentrated watercolor. I attached two Fauxto strips and a headline from a newspaper with glue stick. I rubberstamped my journaling and a small flower near the top, then added white accents and scribbling with a correction fluid pen.

EPICENTER

Epicenter

Where did your quake start? The center of major shake-ups might look lovely, and the ground may move only gradually at first before buckling in at fault lines. I wanted a simple image with a sense of foreboding, so I used white space purposely. I painted the bottom-right corner of watercolor paper with yellow acrylic paint, then used the dripping paint technique with black concentrated watercolor at the top. I used glue stick to attach a small photo of our parents on their wedding day and clipped text from a newspaper.

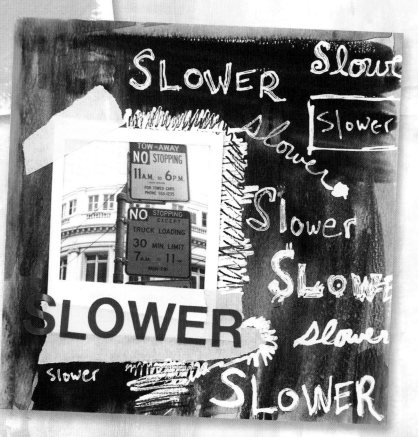

Slower

Some days I have to talk to myself to stay calm and focused. On this day, I chanted, "Slower, slower," as if the mantra were a cross held before a looming vampire. It helped, but I suspect the vampire will return. To convey my mood and thoughts, I basepainted watercolor paper with black, brown and orange concentrated watercolors. I attached a Fauxlaroid with masking tape, then scribbled around it with a permanent marker and correction fluid pen. Just as the words repeated in my head, the words are written here over and over with a correction fluid pen. I repeated that word again over masking tape with vinyl sticker letters.

Sprinkled

The only hard thing about making this page is not eating all the cookies first! The base of this page is a color-copied photograph of street art. I added some drippy yellow paint on the left and attached a journaled Fauxlaroid to the page with masking tape and duct tape. On the right, I turned trash into art! I attached the white paper that had been sitting in the wet ink on my work surface for a "sprinkly" effect.

sprinkled with emotion

Stuck

Reuse! Recycle! The base of this page is a piece of a cardboard box. I stamped STUCK on a piece of paper I'd painted with concentrated watercolors, then embellished the word with white correction fluid pen. Before attaching the paper to the cardboard, I pressed blue ink pads directly onto the cardboard for texture. I glued my paper to the cardboard with glue stick and added a piece of duct tape. I used clear packing tape to attach a real leaf from my garden and added my handwritten journaling with a permanent pen.

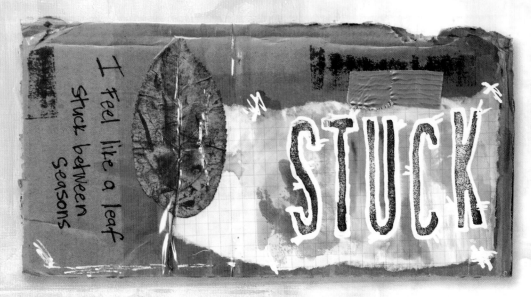

I feel like a leaf Stuck between Seasons

STUCK

Losses and Wins

One day when it seemed I was on the losing side of things, Karen and I concluded that, after all, things usually even out: We DO win some and lose some. Then we got giddy and laughed at how my initials are the same as "Losses and Wins." Silly laughing really does cure most things! I used a blow pen to create the look of my spray-painted initials on scratched and sanded beige paper. Then, I handwrote my journaling with a permanent pen and rubberstamped the page with my own monogram stamp.

an endless Cycle of losses and wins

LIW

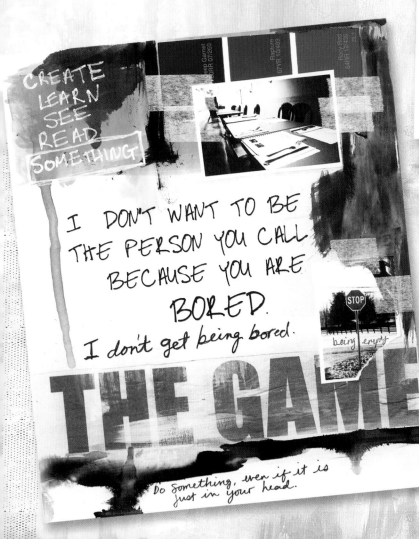

CREATE
LEARN
SEE
READ
SOMETHING

I DON'T WANT TO BE THE PERSON YOU CALL BECAUSE YOU ARE BORED.
I don't get being bored.

STOP

being empty

THE GAME

Do something, even if it is just in your head.

Bored

Invariably, my phone rings when I am covered with a deadly mix of glue and paint. This page vents my rage at tripping to the phone and dripping paint on the floor, only to hear that my friend had called just because she was "bored." I covered a piece of watercolor paper with torn newsprint paper using Mod Podge. I used the dripping paint technique at the top and bottom of the page. When the page was dry, I attached clipped text from a newspaper with glue stick. I randomly (freestyle!) painted white paint over some areas. I attached a torn paint sample and images with glue stick, then embellished with first-aid tape. I handwrote my journaling with permanent pens and white correction fluid pen.

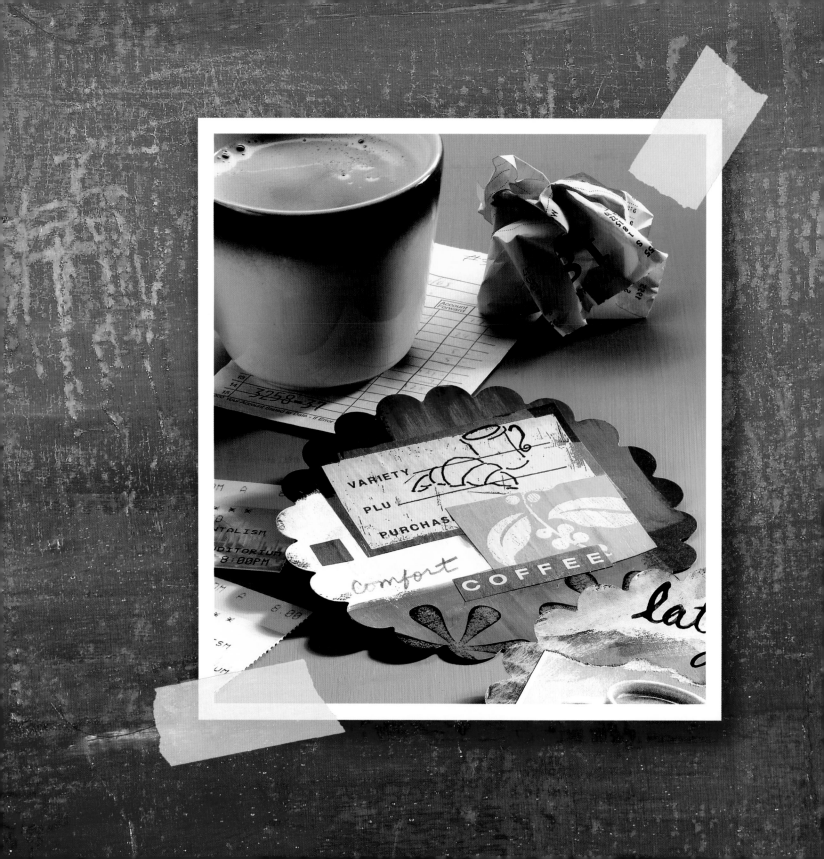

STAGE SIX
Create a Diversion

Rebellion and revolution are hard work, no doubt about it. Excavating feelings, even for art, can leave you hungry, thirsty and ready for mindless fun. And, let us not forget: All work and no play makes Jack a dull boy. A little diversion keeps us refreshed and ready to face the world.

Journaling doesn't have to be for only serious, emotional art. In your journal, you can show who you are when you are off duty. What helps you relax? How do you clear your mind? Where do you play, now that you have outgrown the seesaw and swings? Let your mind and your scissors wander to these lighter topics, so you can round out the picture of you in your visual journal.

Whether your hobby is knitting, wine tasting, playing lacrosse, collecting comics or reading, you can bring bits of your hobby into your journal. First, bring a camera everywhere. You don't have to have a great camera—you can even use the one on your cell phone. Just take pictures! Take pictures of the everyday scenes in your life: your knitting needles perched on your dinner plate, the feet of the hundreds of people waiting in line at the anime convention, the mark of your lipstick on a wine glass. If you take a morning walk past the same mailbox every day, take a picture of it. Stop on your way to your favorite museum and take a picture of the subway tunnel you know so well.

All these images of your routine days will give life to your journal pages. Even pixelated pictures work fine— your goal is to capture a memento that will trigger feelings for you.

Gather ephemera on your way, too. While you are at the anime convention, keep your receipts, pamphlets and ticket stubs. Save some of those charming coasters from the coffeehouse where you do crosswords every Sunday. After whipping up a masterpiece in the kitchen, keep a few wrappers to prove you achieved gourmet chef status this week. You can put these dimensional items in your journaled art. You can even journal right on these items. Just as you have expanded your notions of what goes in a journal, expand your notion of what makes a journal. A menu, coaster, plate, box, bag or pamphlet could become a journal. You could create a whole new hobby out of designing unexpected journals!

SOUND OFF:
TIME OFF

Journals showcasing how we relax and restore are fun to make and easy to share. These journal pages can include pictures of the friends who participate with you, and can be in several formats. You can take a chronological approach, showing a day of hiking and canoeing from start to wet, dirty finish. You might use ephemera to depict the different corners of your beloved sewing room. You can use words and color alone to express your progress through a challenging transformation.

These are journals you and others like to look at over and over. They tell the story of your days and how you spent your time. You can have a bound journal or journal box dedicated to one topic (such as cooking or gardening), or you can toss your loose, journaled pages all together in a decorated "Time Out" journal box. In *Visual Chronicles*, we demonstrated how we like to decorate boxes to hold our loose pages. We usually put our hobby pages in a journaled box. YOU are the boss of your journal. Call your pages whatever you like, and store them wherever you like. As long as you like making them, we are happy.

Three Cups

Ahh, I wish I had more time to devote to the "hobby" of sitting in a bookstore café, sipping a warm drink and skimming books. I love this coffee-colored paper—it reminds me of coasters from an old diner. I snapped photos of my drinks, cut them out and glued them on with glue stick. I added my wording with vinyl letter stickers and handwritten journaling in correction fluid pen. The swirly steam is a rubber-stamped image.

Coffee Comfort

With this page, I wanted to capture the feelings of comfort and nature that can flow through a good cup of coffee. I painted another sheet of the brown paper with acrylic paint in white, orange and green in a random grid pattern. I rubber-stamped a flower pattern in the green section, then layered on pieces of a coffee bag using a glue stick. I handwrote my word with a pencil, then I rubber-stamped the image of the cup and croissant.

VARIETY

PLU

PURCHASE

Comfort

COFFEE

Late Night/Early Morning

My "time off" often occurs only in the late night or early morning. Those late and early day colors appear on this page, which is highlighted by the black background. I randomly painted the brown paper with yellow, blue and white acrylic paint. I glued on a torn photo of my coffee cup on my desk, then painted part of it yellow. I journaled on the photograph first with permanent marker, then near the top of the page, with ink. Finally, I added a rubber-stamped postage-cancellation image.

late nights and early Mornings

with a side of e-mail

restore balance

Yoga

In the midst of a rebellion, it is good to clear your mind. Do a little yoga! I basepainted cardstock with blue and green concentrated watercolors, using the drippy paint method. I found an image of a woman doing yoga and attached it with glue stick. I painted her face beige so she wouldn't sue me, and so I could pretend I had a body that good. I rubberstamped the letters, then lightly sprayed them with water. I handwrote my journaling in permanent pen on the photo and glued on some clipped text.

mind body

Calmed Mind

Wow, it really does work: If you stop to breathe, you see and create more clearly! I cut the hand image out of a magazine, then attached it to scrapbook paper with glue stick. I journaled with brushed-on ink, then painted boxes around some words with white acrylic paint. I rubber-stamped flower images on white paper and glued them on the page. I rubber-stamped the leaves with black ink.

the colors are cleaner and my mind is calmer

E-mail

Ahhh . . . if I had a quarter for every minute spent reading e-mail! To memorialize this time well spent, I created texture on a gray piece of cardstock with the tape distress method. I then randomly painted the page with acrylic paint in blue, purple and light gray (the colors of my computer). When the acrylic paint was dry, I added yellow concentrated watercolors with the drippy paint technique. When all the paint was dry, I attached text from a newspaper ad with glue stick and masking tape. On top of the masking tape, I added the first sentences from several e-mails I received, which I had printed on a label maker. Then, I stenciled gray circles around the edge of the page. I rubberstamped the @ symbol, attached a photo of my eyes at the bottom-right corner and added some wording and doodling with correction fluid pen.

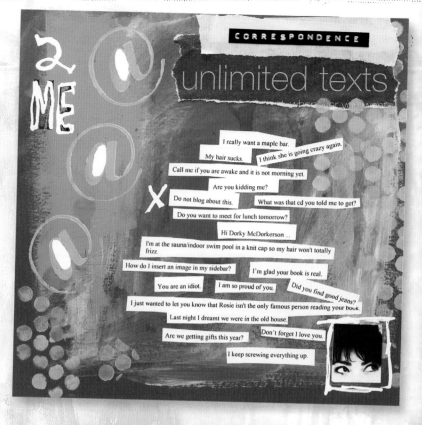

Escape

I like to incorporate some bit of my hobby into my hobby pages. Here, the base of this journal page is the cover I tore off of an old book. I ripped out a catalog image of a full bookshelf, sanded it and glued it to the cover. I rubber-stamped my lettering, then outlined it with a correction fluid pen. I rubber-stamped smaller text at the bottom, too. I always want to just jump into this page to escape . . .

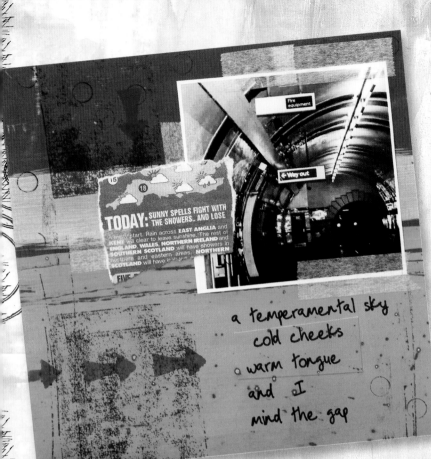

a temperamental sky
cold cheeks
warm tongue
and I
mind the gap

Temperamental Sky

Walking is also a good way to clear your mind. We spent many days of our youth running into train stations to escape rain (and grab a little pastry), as we walked through London. The base of this page is preprinted paper that I texturized by pressing my ink pad directly on it, then added scratches and small circles with the top of my pen dipped in ink. I used first-aid tape to attach a photo of the train station and a torn piece of newspaper to the page. I handwrote my journaling with a pen and rubberstamped the arrows in London-inspired red.

Post No Bills

When everyone else is sleeping, I like to take my camera and explore the city. Just the city, mind you; I'm not a peeping Tom. To create the feeling of slinking about at night, I sanded a light blue piece of paper, then added scratches of dark blue paint. I layered some drippy blue concentrated watercolor and let it dry before gluing on bits of my photos. Once that was dry, I put the page in my typewriter and typed my words directly on it! I then embellished with a correction fluid pen.

Cooking

Paper plates are good for more than just lunch. I painted the paper plate with red acrylic paint and let it dry. I snapped a photo of my favorite mixing bowl and spoon, then cut out the background. I grabbed some wrappers from what I was baking and attached everything to the painted plate with Mod Podge. I scribbled around the images and wrappers with white correction fluid pen, then handwrote my words. With a Sharpie, I outlined the base of the plate and the sugar packets. I added small circles to the rim of the plate with a stencil and acrylic paint.

Little Brown Bag

If finding good deals is your hobby, don't let those shopping bags go to waste! I sanded, scratched and tore this bag (then put it back together with duct tape) before adding clipped text with a glue stick. A photo of my purse is attached with duct tape, and a bit of bar code is attached with clear shipping tape. I used pens for writing and doodling.

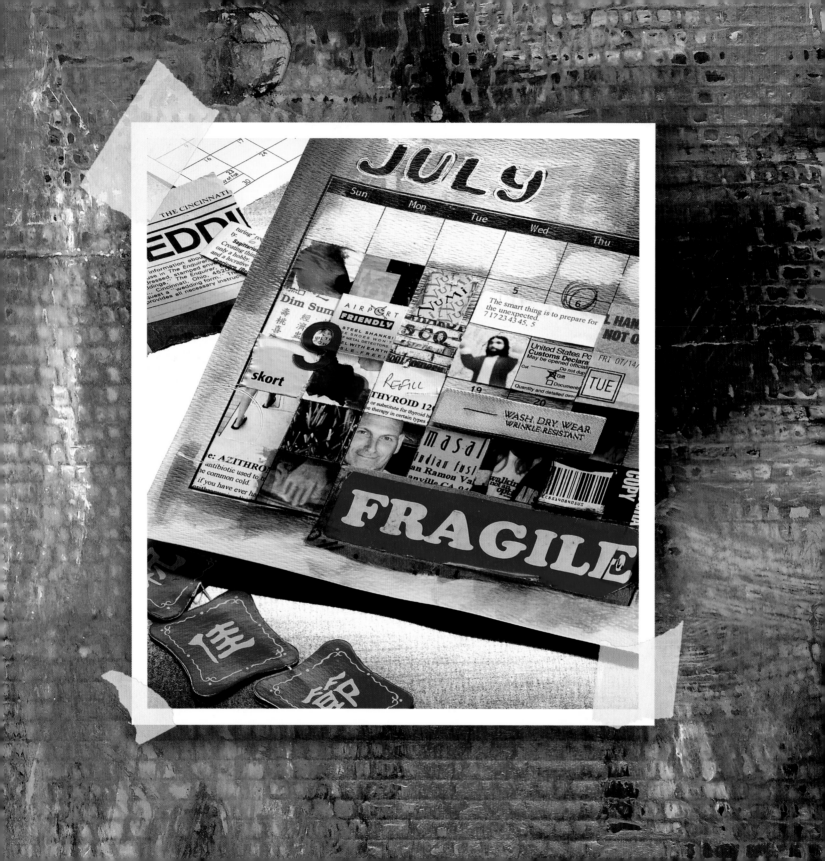

STAGE SEVEN
Plan Your Attack

Planning your attack requires virtually no plan. In fact, art attacks you throughout your day. All you have to do is **let your senses work their magic.** From the song that wakes you up at 6:00 a.m. to the 11:00 p.m. news headlines, you are bombarded with thought-provoking, art-inspiring events, sound bites, textures, aromas and tastes. The world even showers you with proof of your daily battles: to-do lists, receipts, pay stubs, threads, fliers, e-mail, newspapers, buttons. This residue of your life's adventures makes up the art in your day—so start gluing it down!

If you keep a snap-seal plastic bag handy, you can collect treasures from your travels for several days. If you are a control freak, you can label the bags by date, but even Karen doesn't do that. Mind you, if you require a stolen shopping cart to transport your daily ephemera collection, people will suspect you are no longer the boss of your journal.

All these fragments and bits might seem disjointed, but they tell a story when combined on one surface. At the end of a day or a week, choose the element(s) that best captures how you spent your time. You can print out a monthly calendar from the Internet and fill each day's square with one bit of ephemera or one word that reminds you of that day. Taken together, they will portray your otherwise fleeting moments.

Planning your **art attack** with a monthly calendar is dangerously easy and fun. It's like a chocolate-filled Advent calendar: You'll be tempted to jump ahead a day or three. The preprinted calendar takes the guesswork out of where to put your elements—put them in the box, no thinking required. You will no doubt crack yourself up with what you choose for some days.

Plan to notice what is happening within and around you. Plan to snag evidence of your days for your journal. Then, plan only five minutes to present your "daily moment" on paper. At the end of a month, you can bask in at least thirty days of expression (well, except for February). You can bind your collected monthly journals or hang them individually across a wall. **Time never marched on so beautifully.**

ALL IN A DAY

→ → →

When you look back over the mementos from just a day in your life, you can tell a lot about yourself. You might reveal what you have read, eaten, celebrated, worked on, cherished and cried over. Calendar journaling is almost like saving time in a bottle, but it's a lot more accessible.

Freely make your calendar journal your way. No glue stick? Draw something in each box! Can't bear to throw away your tattered, favorite, old sweater? Unravel it and outline each box in its fibers. Are you feeling nostalgic about those chunky, multicolored, speckled crayons? Color with crayons for a month.

You can choose a theme for your calendar journal, if you want. We've made a calendar journal paying tribute to our desperate search for comfortable jeans, and another about the Curse of the Flat Tires that plagued us for far too long. Here are some other themes we like:

* Literary Options - What have you been reading this month?
* Daily Travels - Where did you go on your errands each day?
* Feeling Fit - What sports are you running to and from?
* In Bloom - How is your garden growing?
* Temperature's Rising - What has got you steamed this month?
* Feel the Beat - What music are you listening to each day?
* Best Of - Perfect for December—include the "bests" you have found all year
* Keep Watching - What TV shows held you hostage?
* Say WHAT? - List your favorite quotes from the family or the famous.
* He Loves Me (She Loves Me) - Could you have spent every day rereading the card he wrote you? Copy it, cut out its words, and distribute them among the days

You'll approach each day with a new outlook, knowing that you are searching for that certain something for your calendar journal.

HAVE NO FEAR!

Make a calendar journal as a gift for someone else! Karen treasures the pre-wedding calendar journal Linda made her, filled with little photos, funny words and sentimental memorabilia from the month before her wedding. You might celebrate the month your mother trained for and completed her first marathon. Chronicle your nephew's first steps. Give your loved one a month of extravagant gifts . . . it is the thought that counts.

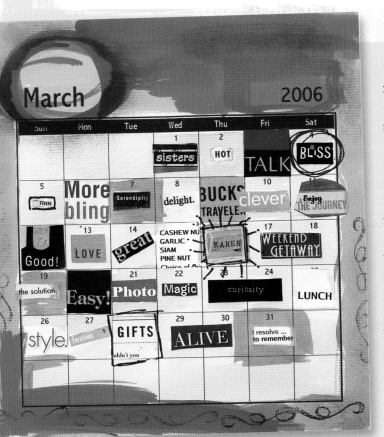

DAY BY DAY

Creating this calendar journal takes merely minutes a day! When the month is over, you will have an evocative, vibrant, journaled masterpiece to show for it. All you have to do is print out a blank monthly calendar page, then snip or tear 1-inch pieces of paper to glue in each day's square. You can fill each square with one word to summarize that day. Find words in magazines, junk mail or newspapers or just write them in. Once the days are filled in, you can add paint, draw or doodle to finish your calendar journal with a background that fits the mood of your month. For other months, choose different methods to capture your days. Try **symbolizing your day** with candid photos, bits of fabric, leaves, shopping receipts . . . whatever has meaning for you!

MESS KIT

blank calendar page
daily snippets of ephemera or text from magazines
adhesive of your choice
concentrated watercolors and brush
rubber stamps and ink pads
black permanent pen

1 At the end of the day (or whenever you want), pick a word that triggers an important memory for your day. Think of what made you laugh today, where you went, what you ate, what surprised you or what saddened you. Just glue the word on the square for the day.

2 At the end of the month, it's time to unify the whole page. Begin by filling in the blank squares with a subtle color, such as gray (watered-down black concentrated watercolor).

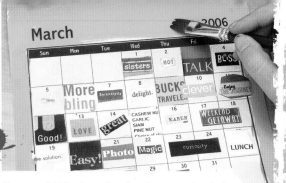

3

Next, fill in the background with a color that conveys the mood of the month. This is our birthday month, so we chose cheery yellow. Dab the color in some of the daily squares, too.

4

Add another color for bold accent. We used red for the overall excitement of the month. Use broad brush strokes, and don't worry about being perfect.

5

Add some stamping to the calendar border to frame your days.

6

A spray-paint look adds texture. With a torn piece of paper, I masked the word I wanted to pop out, and "spray painted" around it.

7

Highlight your days by outlining, doodling and circling in black pen.

70

Sweet Days

It was really tough, but every day for a month, I tried a new piece of candy. I saved bits of each wrapper and every day attached a wrapper to the calendar with glue stick. When the boxes were full, I painted the entire page with concentrated watercolors, then used a correction fluid pen for text and doodles. I rubber-stamped the swirls at the bottom. Hmmm. Now that I think about it, this calendar just does not capture the month properly. Sadly, I am going to have to start all over. Oh, look! A Twix bar . . .

Fragile Summer

July was a busy month of traveling, so I filled these squares with pieces of my busy traveling days. Some days I used photos, and other days I used ephemera. I was on the go and tired most days, so I did it the easy way: I used glue stick for everything. At the end of the month, I randomly painted the page with concentrated watercolors. I used a vinyl sticker for the numeral 9, then doodled with a correction fluid pen.

SOUND OFF:
ONE DAY AT A TIME

Where did the day go? So often we get to 4:00 p.m. and wonder just that. Before we know it, weeks can pass, and we don't know what we've done, why we've been doing it or how come it still isn't finished.

By journaling right in our desktop calendar, we can record what really matters in each day, as it happens. All you need, at most, are scissors and glue. You can keep a running desktop journal with just a stapler or tape, too—tear whatever paper you want to stick on your daily calendar and write or sketch at will on the pages. Each day, add something to the calendar page that represents some meaningful moments of your time. You can cut pictures from magazines, print pictures from your digital camera, use labels and wrappers from lunch or just color shapes and words. Don't worry that your desk calendar also has notes, phone numbers and appointments written in it. Those are part of your day, too, and part of the art in your life.

> ### Blooming Energy
> *This week in April brought gorgeous daisies out the window, a continued appreciation for Tab energy drink and relief that I am not a waitress in a busy, understaffed restaurant! I symbolized these primary impressions in my desk calendar by rubber-stamping some daisies and outlining them with a Sharpie, then doodling stems. I glued in a torn piece of the Tab packaging and a photo from lunch on the facing page. I handwrote my journaling.*

By playing with different art forms in this non-intimidating journal, you can get comfortable with several ways to express yourself. You can fill your desktop journal with the latest fancy mixed-media techniques, if you want. By now, you have mastered the only necessary and most important technique: filling your journal with the genuine you.

In-N-Out Days

On Wednesday, I was so craving a burger. I dreamed of it all day and could barely get through errands before I had to have one. I glued my parking ticket on the page, then added torn pieces of the In-N-Out Burger wrappers and bag. I added rubber-stamped red dots and an X, since that burger hit the spot!

HAVE NO FEAR!

Add ephemera right to your desktop journal or day planner!

1. To add ephemera to any ring-bound journal, just punch a hole near the edge of the ephemera.

2. Then, cut an angled slit from the edge of the paper to the hole.

3. Now, you can easily slip your ephemera onto the rings of your journal or desk calendar, without fear of the added items falling out. Whew!

Oy Vey!
I have a teenager!

① Call the Rabbi!
② Make Kugel
③ Arrange D.J.
→DIET←
④ Touch up roots
⑤ Reserve Ballroom!

A Bat Mitzvah for Emily!

You should come:
October 23, 2007

Don't get so lost:
Temple Beth Shalom
1215 Country Club Rd.

So wear a watch:
10:00 a.m.

You won't starve:
Luncheon immediately following
Grande Hotel~Ballroom
112 North Division Street

Make your mother proud:
R.S.V.P. 818-555-1212

MESS KIT

watercolor paper
concentrated watercolors and brush
computer-generated text
pencil
fine-point permanent marker
glue stick

Some of our most important dates are the ones we celebrate with others. We want just the right card to share our joys, give our thanks or invite our family and friends to come over for really good cake. We've spent literally hours searching aisles of greeting cards for the one that says "Thank You!" or "You're Invited!" just the way we would say it if we made the card ourselves. We're done shaking our heads in dismay at boring invitations, unimaginative birth announcements and generic, too-flowery thank-you cards that just don't suit our styles. Instead, we create personal, journaled greetings and announcements. Our **unique creations** spread the word as only we can; we can't buy our own sense of humor or the heartfelt words only we would know. When you want to send the very best, send your very self.

1

When I announce my daughter is a Bat Mitzvah, I will do it with humor and tell it as Great Grandma Sadie might—as it is. I first used concentrated watercolor to paint the background of the invitation.

2

Oy Vey! I glued my gasping realization to the front of the card, printed in a font that looks like a personal letter from a close friend. My daughter Emily's cut-out picture is another personal touch (for which she will later hate me).

Oy Vey!
I have a teenager!

3

Handwriting the list of all-important things to do conveys my frantic excitement. I penciled in the journaled list to the side of the photo, then wrote over the pencil with permanent ink pen.

4

I printed out the text for the back of the invitation, writing the details as I imagine Great-Grandma Sadie would tell it. I tore off the edges of the page, so it would fit on the card.

5

I used the same concentrated watercolor blue to paint the back of the invitation. When it was dry, I glued the printed information to the back.

6

Vat's dis? I thought. *A little star is too much for my Emily? So some glitter would kill you?* I quickly added a final, symbolic touch: a hand-painted Star of David.

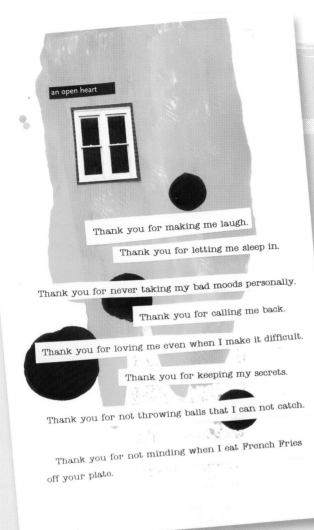

an open heart

Thank you for making me laugh.

Thank you for letting me sleep in.

Thank you for never taking my bad moods personally.

Thank you for calling me back.

Thank you for loving me even when I make it difficult.

Thank you for keeping my secrets.

Thank you for not throwing balls that I can not catch.

Thank you for not minding when I eat French Fries off your plate.

Giving Thanks

The gifts I am most thankful for do not come all wrapped with a bow, and I want to send thank-you cards for them, too. For this all-purpose, sincere thank-you, I painted a piece of cardstock with yellow acrylic paint, then dripped magenta paint on top of it. I printed on white paper the many silent thank-yous I have so often thought and cut them out in separate lines. I attached the text, an image of a window and words clipped from a magazine with glue stick.

a moment
of silence
peaceful

Peaceful Wishes

It's so hard to find the right words and card to convey sympathy. I decided to create my own card, so I could use words, colors and images personalized to our relationship. I painted a piece of paper in warm shades of orange and red. When the paint was dry, I glued down images of a statue from one of my favorite gardens and cut out the floral pattern from scrapbook paper. I randomly added white paint in the areas where I planned to add wording. I then handwrote PEACEFUL in pencil, used sticker letters for A MOMENT, then painted red hearts outlined in pencil. I glued clipped text to the front of the statue image with glue stick.

Graduation

Brent is no ordinary nephew, so no ordinary graduation announcement could do. Cards brimming with pomp and circumstance would never suit a boy so full of humor and irreverence. For an announcement right for him, I used some of his favorite words. Using my photo-editing software, I enlarged a black-and-white photo of Brent and "painted" green in the background. I chose a cool font to echo the unconventional wording of the announcement. The party details are printed on the back of the card.

REPRESENT!
BRENT IS GRADUATING.
BE THERE.

WE MOVED.

WE'RE BUSY UNPACKING AT
1019 VIEWPOINT RD.
WESTLAKE VILLAGE, CA 91361

We're Movin'

This announcement sure beats some lame card with a drawing of a blue jay chirping atop a mailbox! The base of this moving announcement is a photograph of an arrow on cement. I added a cut-out image of Karen's family, secured with glue and tape. I glued on clipped text, doodled around the edges with black pen, then taped around all edges of the card with packing tape. I scanned my master image, then printed it directly on blank postcards to mail. Karen paid me in free legal advice, too—haha!

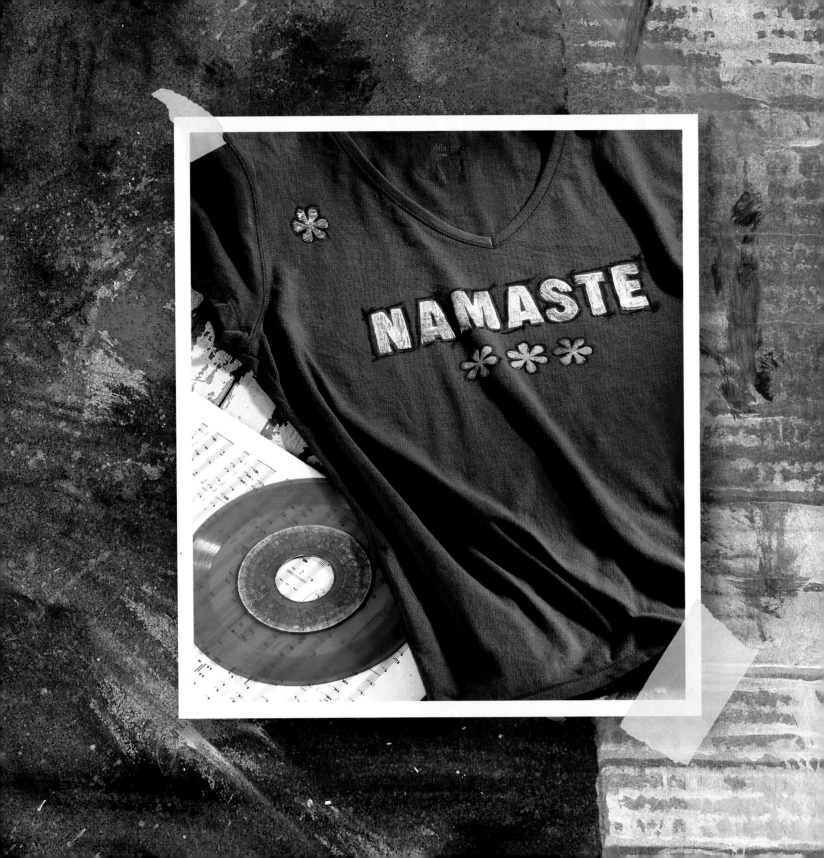

STAGE EIGHT

Take Cover

Journaling isn't just for the inside of books and for loose pages inside decorated boxes. Your artistic insurrections and personal manifestos can proudly cover CD cases, books, bags, floor mats, pillows, even you. You can personalize and "artize" from your bedroom to your boardroom. Yes, your coffee mug is your journal, your bra is your journal, everything in your life really is part of the "journal." **Life is art, baby. YOU are art.**

Cover your spaces and yourself in colors, textures and words that express your truth, your beauty. Marketers, pollsters, magazines and media try to tell us what is cool and who we should be. Do not be fooled. As the winds of popular opinion swirl around you, you don't have to float like a little lost leaf about the scary skies, pushed this way and that by every gust. You can ground yourself firmly and stay on your course. Artists in every realm are here to help you. Even the music you love is a journal: Songs are journal pages other people write for you and put to music. Fabulous food is a journal page a chef has baked into a meal. The tango is passion, blood, rhythm, fervor, all journaled in dance.

As you expand your borders and your concept of art journaling, you'll notice that you suddenly have a lot more to say. You'll also hear more of what others are saying, through whatever channel they express themselves. You might have a new love of architecture now, seeing that even buildings are journals.

Your physical surroundings are your grandest journal. You are leaving your mark, whether or not you intend to. So gather your passion, your rhythm and your fervor, and **journal your life.**

HAVE NO FEAR!

When you think you are "taking cover" in your art journals, the truth is, you are speaking for many other people. Speak your truths boldly on journaled surfaces others can see, and the truth will set you all free. Journal a Lazy Susan with your frustrations about running in circles and getting nowhere. Let your napkin holder extol the joys of getting food all over your face. Your flower pots can announce what wishes grow inside. This type of journaling will spark conversation, laughter and closer relationships.

JOURNALING OUTSIDE THE BOOK

If journaling inside the book seems daunting, you might be tempted to smile politely at this chapter but never really try its tips. Or in an abundance of fear and caution, you might rush to the bookstore to buy a few more books specifically geared to techniques for fabric painting, embellishing purses, faux-finish murals or mixed-media assemblage. Please hear this: You do not need to know any fancy techniques. Some of the most stunning, moving art journals are incredibly simple; their beauty lies not in the artist's ability to master six techniques on one surface but in her ability to convey one genuine emotion.

You can start with the emotion or the object; it doesn't matter. If you have a bench you are dying to transform, put down some newspaper, grab your little mess kit of supplies and get eye-to-eye with that bench. Run your hands over its form. Now, don't think: Feel. Go from information to inspiration. What secrets does the bench hold? What changes has it witnessed? Did you experience any revelations while resting on it? Does it remind you of benches in far-away lands? Perhaps your bench looks like someone you know or it looks the way you feel. Your intuitive response will give you the words and images for your journaling.

Next time you have a brilliant thought while driving, journal it on a T-shirt when you get home! Create a stir at the next Little League game by wearing a journaled cap. Instead of proclaiming that your tush is "juicy" or "hot," journal your sweats with personal doodles and phrases. Your home can come alive with expressive art, too. "Home Sweet Home" is comforting, but your pillows can comfort with your words. To your French bistro curtains, you can add journaling of your dream vacation in Provence. The possibilities truly are endless. Do spare us the polite smile and join us as we journal outside the book.

1 FIND ANOTHER FOOL

2 HATE ME

3 I WILL SURVIVE

4 ANYTHING, ANYTHING

5 YOU OUGHTA KNOW

DEDICATIONS

VOL. 2

MESS KIT

decorative paper
removable tape
black ink pad
bristle brush
white acrylic paint and another color of your choice
brush
cap or other object to stamp with
fine-point permanent marker
computer-generated text
number stamps
white correction pen

Just as movies have soundtracks, we can make soundtracks for the different storylines in our life. Create CDs that suit your moods, your eras and your activities. You are bound to need some dramas, a little romance, a few tearjerkers, the action score and comic relief. Once you have the soundtracks for your life, create covers that match the music. Here, we are making a cover for a CD with empowering, only slightly vindictive songs dedicated to breakups (uh, yeah: that's Volume II), so a battered floral cover will work.

1 Choose a decorative paper that fits your theme and trim it to 9½" × 4¾" (24cm × 12cm). Fold in half. On the left half, apply removable tape where you will place your song titles. Use a bristle brush to pounce ink over the cover, and then then peel off the tape.

2 Use a found object or two to add some random texture. Here I used a medicine bottle cap for broken rings, then rolled around a ridged eye-drop bottle lid to simulate track marks, like the tracks that bastard left on my poor heart.

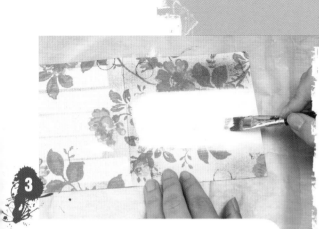

3

On the right half, paint white over an area of the cover where the title will go. You can use whatever color will work as a background for the font and color of your title.

5

Those flowers look a little too sweet. I'm going to outline them in black to toughen them up.

4

Add emotion to the title side with brushes and card swipes of bold, red paint. Awww, man! I dripped red paint right onto the white title area. Figures. Okay; I'll make it work!

FIND ANOTHER FOOL

HATE ME

6

Print out your song titles and then cut them out in strips. Glue the song titles in the spaces you made on the left side. Stamp numbers next to the song titles.

7

Now, to deal with the drip in my title area. I can't turn it into a flower . . . but I can make it part of my art. It looks like a red teardrop, kind of. It conveys pain, in any case. I'm going to stamp my title in jumbly letters, and let the "mistake" fit in.

9

Using white correction pen, I will confess to this being Volume II. The correction fluid works well over the red paint.

The final CD cover has a grungy, battered look, perfectly matched to the songs. And that red drip looks great! When you are journaling, don't stress if paint drips or you mess up on your stamping. Just cross it out or work it in. **Mistakes are part of life's art, too.**

8

The song list looks too calm and orderly, so I am going to quickly outline the numbers in black pen. Now it looks rougher. The contrast between the formerly pretty paper, the "proper" style of the font and the black scratches and distress marks perfectly captures the mood of this CD.

Beautiful Noise

Brooklyn Roads

I Love L.A.

Lights

London Calling

Nights on Broadway

No Sleep 'Till Brooklyn

San Francisco Days

Vienna

IN THE
CITY

In the City

*Alive with songs that put me in the
heart of my favorite cities, this CD needed a cover that honked
and rushed. I used black paper for the base of the cover, then haphazardly painted the
left side with white paint. I used the drippy technique on the right side. I cut out a photo of a taxi and
attached it with glue stick. Above the taxi, I used vinyl letter stickers for the wording and rubber-stamped a
swirl. On the left side, I printed out the song titles on yellow paper, cut them in strips and glued them on.
I used the eraser of my pencil as a rubber stamp for the red circles.*

At Seventeen
Everything I Own
Harden My Heart
How Soon Is Now?
It's A Heartache
It's Gonna Be A Long Night
Jessie's Girl
Jolene
Loser
Love Hurts
Not Pretty Enough
Patches
Pictures Of You
Songbird
Sylvia's Mother
The Breakup Song
Total Eclipse Of The Heart

Woe
is
ME.

Woe Is Me

*Here is my Pity Party Mix. Be warned: The song titles
alone might have you reaching for a tissue. The base
of this cover is polka-dot paper that is sanded and
scratched. I cut out a photo of a box of tissues and
attached it with glue stick, then handwrote the title
with pen on the photograph. I wrote out my list of songs
on white paper and ripped around the edges. I attached
the list with glue stick and masking tape. To add
emphasis, I circled one song with colored pencil and
stamped on the arrow image.*

Years ago, we had a great week-long trip with our cousin Leigh to Manhattan and Boston, filled with spills, trips, getting lost and finding our best selves. Instead of buying T-shirts with generic *Broadway* signs on them, we went into a shirt shop and made our own shirts. We used special pens to sketch the snob who tried to evict us from The Plaza, the twinkling lights of Tavern on the Green, Linda's wild hair, Karen's "new attorney" briefcase, Leigh's search for a perfect orange and priceless self-portraits of we cousins. Our masterpiece was transferred to our Ts, making the best souvenirs ever.

Make souvenirs of your days. Chronicle your brilliant one-liners. Wear yourself proudly!

Rise Up

Don't be shy about your creative revolution—shout it out. Others will then feel freed to show you their creations and create with you. On this shirt, I stamped the words and swirly motif with fabric paint mixed with textile medium. For the lettering, I first stamped using beige paint; when it was dry, I added touches of blue paint with a paintbrush. I also added dabs of blue in the swirly pattern. When all the paint was dry, I pressed my permanent ink pad directly on the shirt to create texture. I also stamped circles with found objects and permanent ink. I outlined the letters with permanent pen. Follow the textile medium manufacturer instructions for heat-setting your garment.

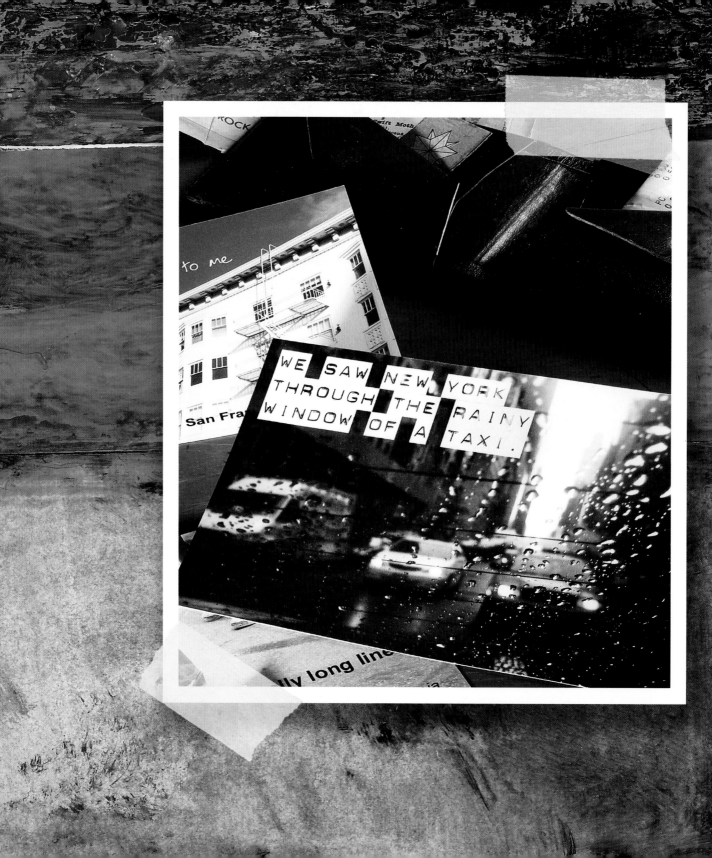

STAGE NINE

Reconnaissance Mission

Grab your camera, stuff a notepad and pen in your purse and GET OUT! Survey the territory. You can pretend you are mailing letters, getting groceries, taking kids to soccer or picking up the dry cleaning, but you really will be conducting surveillance.

What's going on out there? Your mission is to chronicle and document the lay of the land, the appearance of the people, the sound of their language, the value of their currency, the taste of their cuisine, the colors of their streets—right down to the look of their shoes. Nothing is too mundane for your log. And while you are at it, turn your camera around and snap a few pictures of you mixing in with the locals.

While you go through your daily routine, take pictures of your stomping ground. Take notes of why you follow your routine and where it takes you. Look with fresh eyes on the familiar and question what you see:

* What is it about that fruit stand that draws you?
* Why do you wear those shoes to walk every morning?
* What trash is in the gutter at the corner?
* What does it look like your neighbor is eating for breakfast?
* What does your co-worker wear every Thursday?
* Are there any new pastries at the bakery?
* When can you park on Main Street?
* How long has that broken chair been on the corner?

TURN AROUND!

→ → →

Don't forget to look behind you. There's a world behind you (maybe even pointing at you). There might be a swimming pool behind you, into which you could unexpectedly fall, as Karen once did! Now *there's* some great journaling. Literally and figuratively, look where you are not going, too: You can find a lot to journal about in the paths you did not choose.

In addition to journaling about your hometown reconnaissance missions, you can approach vacations and business trips with the same goal to make art of the everyday life you observe. When you venture out of your real or imagined neighborhood, take notice of the new colors, textures, scents, sounds. The poem we learned as little kids still has a point—look up, look down, look all around, and consider:

✱ What does the sky look like here?
✱ What are the predominant colors here?
✱ What is the ground like?
✱ How do people here get around? Cars? Taxis? Buses? Boats?
✱ What doesn't belong? As you scan the horizon, what catches your eye?
✱ How do the people look? Long hair? Beards? Makeup? Odd makeup? Stuck in the '80s?
✱ What's the news-o-the day? Listen in the grocery store line: What are the locals discussing?
✱ What's graffiti like here?

Come back from your reconnaissance missions with lots of pictures, scribbled notes, directions scrawled on maps, receipts from diners and flyers you picked up on the street. You'll be ready to make tell-all journals on T-shirts, canvas, paper or postcards.

SOUND OFF:
ON LOCATION

Like an impressionist painter, you can make journal pages that quickly capture your on-the-spot impressions of a city or location. Use the colors that flooded your senses, the overriding images of the location and the words that ring most clearly in your mind. When you think of San Francisco, for example, a flurry of images probably comes into your mind: the Golden Gate Bridge, blue waters, rolling clouds, sourdough bread with steaming clam chowder, hills, cable cars. This mishmash is San Francisco. You do not need to make a whole, annotated photo album with approved page layouts of your San Francisco weekend. You can say and show as much with one collaged On Location journal page that looks like just what San Francisco looks like in your mind.

Try to make your On Location page quickly without thinking a lot about it. Just breathe and feel the location. Remember the answers to the reconnaissance mission questions. Then move the colors and images from your head to your art journal surface. So long as you don't show your art to your therapist, all should be fine.

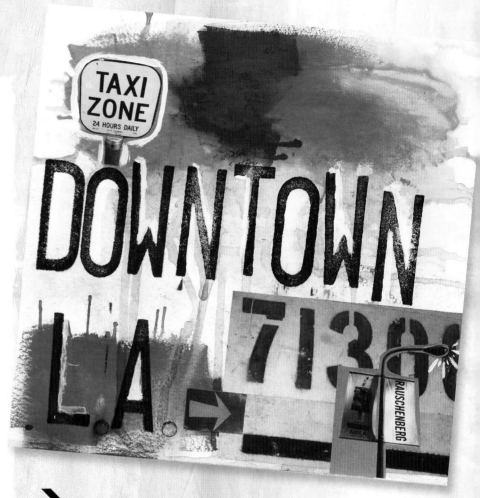

 Downtown L.A.
I made this On Location impression page after returning from seeing the Robert Rauschenberg exhibit at L.A.'s Museum of Contemporary Art. I included two images that were strong in my mind, stamped DOWNTOWN LA, and splashed on the colors that filled my mind's eye.

Santa Barbara

Sand, flowers and architectural elements—Santa Barbara conjures these images for me. I love the colors of Santa Barbara and used them as my background. I painted the colors of Santa Barbara in organic shapes with concentrated watercolors, letting the colors drip and run into each other. When the page was dry, I rubberstamped shapes and texture with ink. I handwrote my journaling with a black pen and attached a piece of decorative paper with glue stick.

The Salon

Going to the salon truly is seeing an old friend. Our stylist and colorist, Lisa Oliver, has been doing our hair since . . . well, let's just put it this way: We've all been through blue hair and hair extensions and back again, together. Lisa is beyond cool, and never takes herself too seriously. I needed a journal page that had the same cool, yet fun, feeling. I painted the paper a deep red, then used glue stick to glue down torn photos from my day at the salon. I added metallic silver paint around the images and used a straw to blow the drips in the direction I wanted. When the paint was dry, I added black tape, rubber-stamped images and text, then outlined them with a metallic pen.

SOUND OFF:
JOURNALED POSTCARDS

Most mass-market postcards are photos of tourist attractions, with conventional stock photos on the front and on the back, a three-line description of how beautiful the place is. When you create your own postcard, you can zoom in on the unique, the ironic, the delicious parts of town not usually featured on postcards. You can use your favorite fonts. You can insert yourself in the picture and control whether your hair is frizzed and your face is double-chinny. You can show others the view you saw and tell it like it is. No spin but yours.

It is simple to make your postcards by hand: Just print out a photo and write on it or glue on words or ephemera. You can also play with your digital photo-editing software and make postcards in no time. These are so much fun, you won't wait for a trip to start sending them.

Create postcards from your imaginary trips or your regular days. Everyone loves getting friendly mail.

The clouds are different here.
The Middle of Nowhere, Arizona

Clouds
One thing we noticed as we took a road trip to Arizona was how different Arizona clouds are from southern California clouds. In fact, we noticed it every day of our trip. I took a photo of the curious clouds and added my observations with photo-editing software. I chose a simple font that would not distract from the clouds.

Rush Hour in Kentucky

Rush Hour

We came to this intersection at 5:00 P.M., on a Tuesday evening in Kentucky. We couldn't help but laugh at the irony of the sign. The Kentucky version of traffic congestion is not at all what we're used to. I journaled my tongue-in-cheek comment by hand, right on the photo, with a permanent pen.

New York

There's something really cool about riding through New York City in a cab. It's even cooler when it is raining, because you can see New York without your hair getting all frizzy. I added text to my photo using a font that reminded me of the signs we saw.

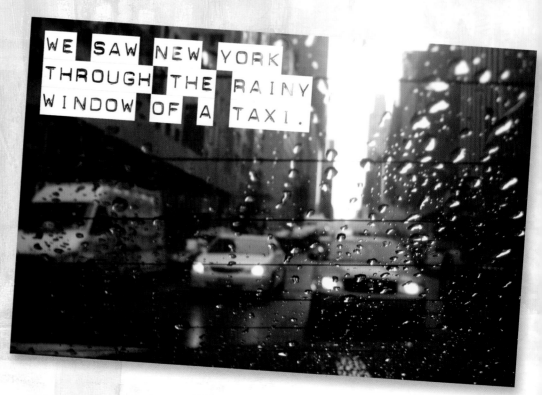

WE SAW NEW YORK THROUGH THE RAINY WINDOW OF A TAXI.

Really long lines.

Santa Monica, California

Long Lines

My friend and I spent the entire day going to one art exhibit. We stood in line for hours and entertained ourselves by people watching and taking pictures of what we saw. My main memories from the day are The Longest Line Ever and all the sandals people were wearing. I chose a simple, straightforward font and added the text with a photo-editing program. When I later sent this postcard to my friend, she laughed for days.

Red

My heart and my stomach belong to San Francisco. One sunny day during a picnic in the park, I looked up and saw this set of red curtains. After that, I began noticing bits of red around the neighborhood where we were and started photographing all the glorious color. I added journaling in my own handwriting where clouds would be.

Little bits of red scattered throughout the city called out to me as I walked by.

San Francisco, California

97

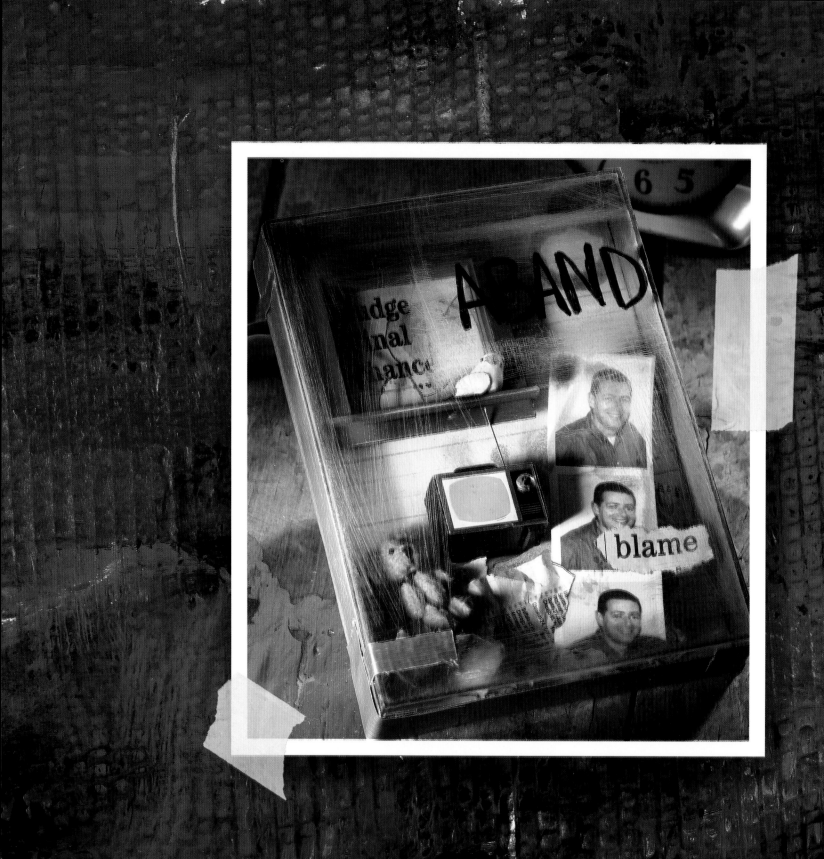

STAGE TEN
Trespassing Zone

Bottling is for fine wines, old-fashioned root beer and notes tossed into the seas. **You don't have to bottle up your emotions or your art journals.** The insightful, funny, thankful, releasing art you make while journaling can be displayed throughout your home and office.

Your friends and family will get a kick, or a kick in the pants, out of seeing what you have been up to. You can keep your bound art journals distributed around your home, so guests can pick them up and flip through them when they visit. If you have deeply personal journals, with pages on which you vent unresolved anger from childhood, or from yesterday, keep those in a drawer or a closet where you won't be constantly nervous that people will see your caricatures of them.

You can also display your decorated journal boxes with loose journal pages inside. Set a box on your coffee table or mantel and watch as guests peek through the treasure chest. You might even leave out some index cards and journaling supplies and let your guests add their current journaled thoughts to your collection!

For those of you who are tired of being "shhh'd" and of sitting still: **Rise up! Create and create loudly.** Your art will beat throughout your territory, as your heart beats within you. Make it part of your manifesto that you will display your art. You will enhance your territory by taking your place in it, by shining side-by-side with the sun. If that makes others put on their shades, so be it. **Hear your voice, see your colors, touch your feelings and know that they are real and respected through your art.**

DISPLAY YOUR BADGES

You can afford to surround yourself with cool art, even if you live on a tight budget. You know an artist who gives your hopes a shape and your feelings a color: you. When you display the art you made, it's not purely decorative; it has meaning and sentiment to you. The everyday journaling you do makes great wall art, or you can make something specifically to hang on the wall.

Be imaginative with your presentations of journaled art. Display some of your Fauxlaroids alone, as art. Exhibit several finished Fauxlaroids together on a photo tree, each one clipped separately. Or, use fishing wire and small hooks to make a mini clothesline across part of your wall and clip each Fauxlaroid to the clothesline. These displays work great for artist's trading cards, too. You can change the display as you make or receive new ones, and your co-workers or guests will love your cleverness!

Slide your 4" × 6" (10cm × 15cm) journaled pages into magnetic photo frames, and decorate your refrigerator in an artistic repast. Cut out smaller journaled art bits and glue them on magnets to make your own refrigerator magnet puzzles or mosaic activities. While you're there, grab a spoonful of frosting from the fridge before you move on to the next project.

Frame your journal pages in ready-made frames—it's easy, and there are so many styles to choose from. Pick distressed wood, floating glass frames or shiny metal—whatever matches the tone of your art journaling. If you time things right, you'll find that frame for one cent or at a two-for-one sale. If you journaled four pages on a certain theme, use a collage frame to display four pages together. You can even alter ready-made frames to fashion the perfect fit for your journaled art (see how we did it, on page 107).

If the walls had ears . . . they would hear all about your journal and wish they had paper. Fulfill your walls.

motion
noise
beat
growth
static
united
flow
cycle

29th

I AM ART.

Once you start journaling on big canvases, you'll be hooked. Instead of fearing the initially empty space, you will be overflowing **with ways to put yourself on the wall.** You have all that room to brush, splatter, drip, collage and stamp . . . and if you make a "mistake," you have enough space to just stick a photo or fabric over it. **Treat the canvas like a journal page.** Have fun expressing yourself, and you will love the result.

MESS KIT

- blank canvas
- gesso
- various acrylic paint colors, including a neutral shade
- brush
- decoupage medium
- photos
- sandpaper
- any other pieces of ephemera
- straw
- spray bottle
- inks or concentrated watercolors
- detail brush

1

Squirt a generous amount of gesso onto the canvas. Don't just skip this gesso step; it really does matter. Without the gesso, the canvas will absorb your paint awkwardly, and you will get annoyed.

2

Spread the gesso around with a brush, until you have covered the entire front of the canvas. Don't wear your best sweater to do this. Let the canvas dry. Next, paint a neutral base color on the canvas. Here, I'm using light mocha. I wanted the feel of a city in motion, of flux, imperfection, movement, so I didn't cover the canvas completely but let some of my brush strokes show.

5 Brush additional decoupage medium over the fabric, then add any final elements to the canvas, like my sporty little taxi here. Next, add some different colors of paint around the photos and edges of the canvas. Use big, fast strokes—don't be all shy about it. Brush on bold color and brush it right onto your photos, if you want.

3 While your canvas dries, decide how to arrange your photos. Go ahead and mix photos that have been cleanly cut and those that have torn edges. Before attaching photos, I scratched and sanded some. Brush Mod Podge onto the backs of the photos, then adhere them to the canvas. Brush more medium on top of the photo and smooth it down with a brayer. Note: Photos from an inkjet printer may smear when you brush glue over them. (Could be a cool look, though.)

6 Make paint stamp imprints on the canvas, with textured objects from your home. I used medicine bottle lids, not because I am a walking pharmacy, but because I like the broken circles they create. Then, to create a visible place for the writing and other paint effects on this canvas, I painted some white over the yellow.

4 If you are adding fabric to your canvas, first brush a generous amount of Mod Podge onto the part of the canvas where you will place the fabric. Then, press the fabric (we cut out part of a T-shirt) into the decoupage medium. It's OK if fabric threads get in the paint or all over the canvas. It happened to Rauschenberg, too.

9 Don't think that your drips should go in only one direction. You can turn your canvas upside down and make them run the other way, too!

7 To get an edgy feel with dripping paint, spray the top portion of the canvas with water (mask off your photos if they're not waterproof, unless you want them to run, which can be cool, too!). Then brush on a few colors of paint, spray on more water and hold the canvas up to let the colors run. Tap the canvas against a table lightly to get the paint dripping better.

10 When we think *city*, we feel a magical mix of competing images, somehow coexisting. This mix is art, like the art we all are. I picked photos to show this mix and journaled with words that convey the feeling of a city to us. I first penciled in the words, then went over them with a brush and ink.

8 Here's a good drippy paint "cheat": Use a straw to blow some of the paint around further. You can sort of get it to drip where you want it this way, too.

11 When the ink has dried, you can erase the pencil lines, if you want. Seeing the pencil beneath can be interesting, too. I painted the sides of the canvas black to finish it off.

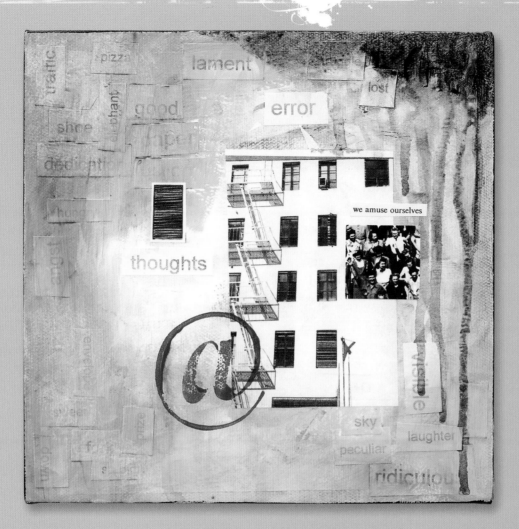

Thoughts

My walls are talking now! I had a day of a zillion thoughts running through my head and wanted to convey the onslaught of words and desire to escape. I sat at my computer and just typed every word that popped in my head. I printed them and cut them out. I basecoated my canvas with gesso, then glued all the words on with Mod Podge. I painted all over the canvas and over the words, with watered-down yellow and white acrylic paints, leaving the word THOUGHTS still visible. When the paint was dry, I glued on images and clipped text with Mod Podge. I used the drippy paint technique for the smudgy sky in the upper-right. I rubber-stamped the @ symbol and lightly sprayed it with water, so it would smear.

Here and There

Between here and there, we are always surrounded and comforted by our Nana's words. Her guidance and love helped us climb from here to there, many times. I basecoated the canvas with gesso, then randomly painted with blue acrylic paint. When the paint was dry, I attached an enlarged color copy of a photo with Mod Podge. When the Mod Podge was dry, I added black acrylic paint around the edges of the photo. I attached a torn piece of a letter written by our Nana with packing tape. When the paint was dry, I added lettering with vinyl stickers and hand-writing with a correction fluid pen. I added more packing tape to the sides of the canvas.

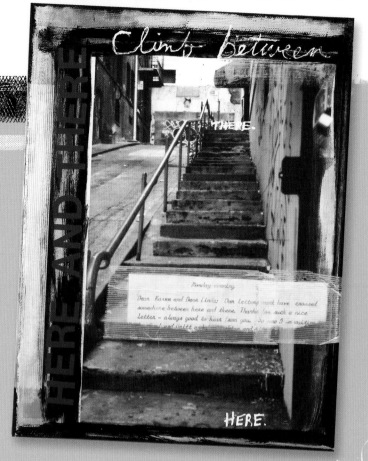

Sheep

Just one sheep can change the direction of the herd. This canvas is a bold reminder that we can all choose which sheep we want to be, every day. It's OK to be the follower one day, the leader the next: What matters, of course, is making the choice. I basecoated the canvas with gesso then painted it solid black with acrylic paint. I used a copy machine to enlarge my favorite photo of a sheep, then cut the sheep out of its surroundings. I glued the sheep to the canvas using Mod Podge. When dry, I used a correction fluid pen to outline the sheep, and I handwrote the words.

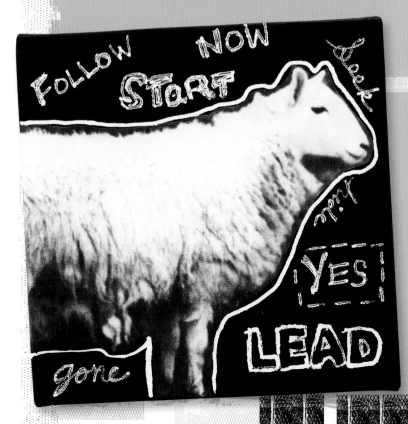

THREE-DIMENSIONAL JOURNALING

→ → →

Oh, how we loved making dioramas in school! We could collect plants and rocks to glue on the bottoms, make cut-out people to stand in them, dangle stars and seagulls from punched holes in the tops, paint rainbows across the backs . . . We created fantastic worlds that defied gravity and time. When we got to do diorama book reports, we always felt that we shared much more than when we wrote: The characters came to life in our expertly crafted, poignantly symbolic, three-dimensional worlds.

We still have stories to tell and reports to give. Our journaling can be three-dimensional, to reflect the depth and layers within us. You can use a shoebox to make a journaled diorama, just as you did in school. Or, you can use any shape or size container you like. Shadowbox frames work well and come in all sizes. They may not be deep enough for what you want to display, however. Wooden boxes and inexpensive, small wall cabinets are fun to work with, too. Sometimes you can get wonderful old wall cabinets at flea markets.

Three-dimensional journaling can be like a time capsule: Tell your year's story with newspaper clippings, photos, ephemera, e-mails and other representations of your public and private life. You can also use dimensional journals to "bury" old habits and worn excuses. Build a safe place inside your journal walls and furnish it with the things and people you love.

Traditional dioramas may be scenes in which objects are arranged in a natural setting, against a realistic background. Yours, however, can be unnatural, unrealistic or surreal. You can combine people from different families and different centuries or even include celebrities in your world. Your beloved childhood pets can return for a romp, and they can talk to you. The dove of peace can perch on your windowsill, even amongst the most warlike times. This is art, and you get to have it your way.

LIFE WINDOW JOURNAL

Look through the window into your life, and make a three-dimensional journal of what catches your eye. You might journal scenes from the past, present or future. Here, we are peeking into an abandoned childhood. By doing so, we can let go of some feelings associated with it and focus more on that dove as the days pass. Gathering the memorabilia and miniatures for these journals can be amusing and therapeutic, almost as fun as making the art. When strong feelings arise in you, give them a room of their own and a window to that room.

MESS KIT

- standard foamcore, 9" × 11" (23cm × 18cm) or larger
- 8" × 10" (20cm × 25cm) acrylic frame
- metal ruler
- craft knife
- school glue
- decorative paper
- glue stick
- concentrated watercolors
- ink
- photos
- ephemera and/or miniature objects
- scissors
- silver duct tape
- sandpaper
- bristle brush
- permanent ink pen

1 Remove the insert from the acrylic frame so you can rebuild it your way! First, rub the ink pad along the bottom edges of the acrylic box and "stamp" the inked box on your foamcore. This creates a pattern for you to cut out the back of your frame. So clever.

2 Use a ruler and a craft knife to cut out the foamcore shape just a bit inside of the inked line—$7^{15}/_{16}$ × $9^{15}/_{16}$ should work great.

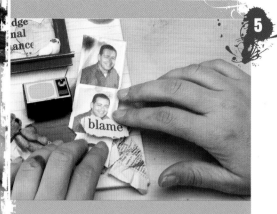

5
Create your dimensional, journaled scene on the wrapped foamcore surface. Our scene is meant to look worn and battered, so we used ink to leave dust and dirt throughout. We had a blast breaking that glass in the window and charring a bit of the Fauxto Booth strip! We used school glue to adhere the pieces.

3
Apply glue to one side of the foamcore and glue it to the back of your decorative paper (our paper here has the same pattern on both sides).

6
If you want an urban, industrial look, before putting on your acrylic cover, apply strips of duct tape to the back of the foamcore, sticky-side up, so the tape sticks out on the sides. Then, spread a thin layer of glue around the four sides of the foamcore.

4
Smooth out the paper over the foamcore to remove all the bubbles. Trim the paper down to leave just enough to wrap it around to the back of the foam core. Notch out the corners, so that they fold smoothly over the back. Apply glue stick to the foamcore and fold the paper down on the back to secure.

7
Set the art on the table, face-up, and then push the box cover onto the glued foamcore. You may really have to push. It helps to say, "Come on, baby!"

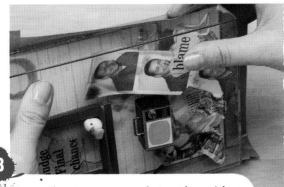

10 Brushing dry ink over the sanded areas creates a smokey, grungy look.

8 Wrap the tape around to the sides and/or front of the box. You can notch the corners, if you want, and add more tape to create the look you desire.

11 Journal on the front of the window, too, like an abandoned shop with graffiti on it. To make a space for journaling, stick tape on the acrylic where you want to journal, then sand around the taped area. Remove the tape and you will have highlighted a nice space to write.

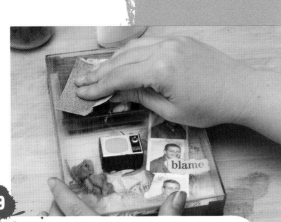

9 We scratched up the window a bit with sandpaper, to make it look more like an old, abandoned warehouse.

12 For an easy hanger, fold a piece of duct tape onto itself and create a loop with it. Then, tape it to the back of the frame. This frame is really light, so this will hold.

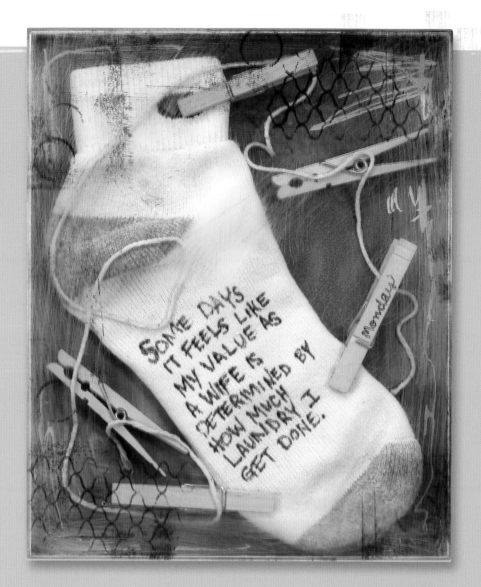

Laundry Day

Am I measured by how many pairs of clean, folded socks remain in the drawer? I made a home for this pernicious feeling, filling it with the bane of my existence. I painted the foam core in shades of blue with acrylic paint. While the paint dried, I handwrote my journaling directly on the sock with permanent pen, and wrote the day on one of the clothespins. I added scribbles with a correction fluid pen. I attached the sock and clothespins to the foamcore with Mod Podge and let it dry. I dipped string in Mod Podge and while it was still very wet, pressed it onto and around the foam core. When the piece was dry, I attached the lid and used metallic tape on the sides. I sanded the plastic lid with sandpaper and pressed a permanent ink pad onto the surface to add texture.

Stretched

I felt pulled and stretched in so many directions, I thought I might snap and go flying across the room. Instead, I made a Life Window journal to hold my energy. I painted the foamcore with purple acrylic paint and let it dry. I painted and embellished a piece of a broken doll with found text, then used Elmer's glue to attach the piece to the foamcore. When that was dry, I stapled rubber bands to the foam core. I covered the foamcore with the plastic lid and secured it with duct tape. I sanded the plastic lid and added texture by pressing a permanent ink pad directly onto it. I used vinyl sticker letters for the wording.

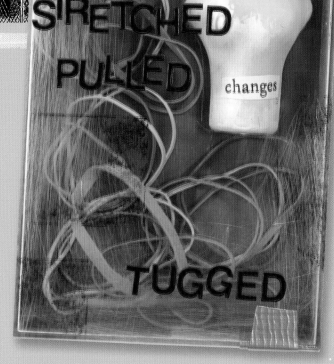

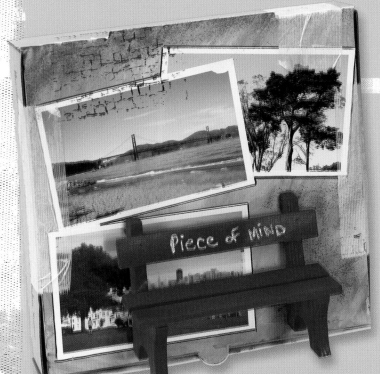

Piece of Mind

The best piece of pizza comes from the cutest restaurant, with a red bench in front, in San Francisco's Little Italy. I journaled on a pizza take-out box for this three-dimensional art, which gives me peace of mind (and hunger) each time I look at it. I basecoated the lid of the box with gesso. When it was dry, I painted it with blue acrylic paint and added a darker blue, faux spray-paint haze. I rubber-stamped texture using black ink. I attached the photos with Mod Podge and packing tape, then outlined them with a black pen. I spray-painted the wooden bench red, then handwrote the words with a correction fluid pen. To finish, I attached the bench with Elmer's glue.

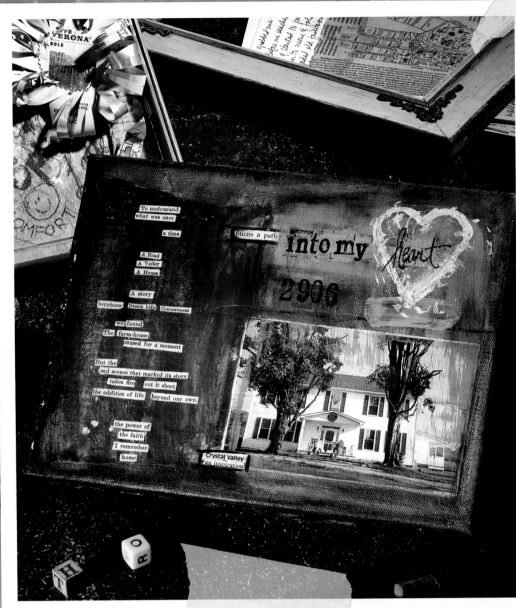

STAGE ELEVEN
Recruit

The Art Army is recruiting, and we want you, your family, your kids and your friends. We even want your enemies—if you get them to make art journals, they will no doubt become nicer people. Once you start marching to the beat of your creative drummer, others will want to follow. Just **enjoy the magic as it happens.**

You can easily involve others in art journaling, and sharing the experience makes it even more fulfilling for you. One unobtrusive way to begin is simply to show your stuff. Frame one of your art journal pages on your desk at work or make your own journaled holiday card. Tons of people will compliment you on it and ask how you did it. Or, bring a few simple supplies to work or to a play date at the park and just start making some backgrounds in a journal while chatting with friends at lunch. Glue in decorative paper, doodle with pens or finish up a page you started earlier. We've tried this and invariably, almost everyone says, "Are you . . . are you coloring?" We admit to our crime. Then their eyes light up and they ask if they can have a pen, too.

Help others turn on that light. You can even involve them directly by inviting them to make art with you. At kids' parties, we assure no boredom by providing all sorts of crafting activities. Do the same for adults. Heck, we are often bored at parties where no one does art!

Set out some index cards, old magazines, markers, tape, ink pads, stamps or objects to stamp with and let the fun begin. You can give your guests some topic ideas to get them going. At a holiday party, have blank cardstock available and encourage them to make some journaled cards.

If you have an instant camera, you can liven up any gathering by taking candid pictures and letting everyone make journal pages with them. Share your recipes for the evening—your friends can make journaled recipe cards. You could also create artist trading cards to trade amongst yourselves at your next get-together.

By creating together, you **discover talents** and **secrets** you might have missed. You'll laugh and get messy, and it just might be the most fun you've had since you were in kindergarten.

E-ART

➡ ➡ ➡ You can create with friends even when they are not with you. With technology these days, "being there" rarely means an in-person meeting. Your art can capture and convey this new definition of a get-together.

Use excerpts from e-mails and letters, even bits of transcribed voice mail messages, to include others in your art. We mean that literally: Print out your instant-message session and glue it on a page. Take a photo of your text messages and Fauxto Booth them. Instant messaging, text messaging and the clever (yet annoying) abbreviated language they inspire say so much about who we are and how we spend our days. Don't forget the icons and smileys you and your friends favor. If your sister loves to punctuate her hatching plans with a certain devilish, smiling face, print out that face to use in your art. If you have a secret code, your own acronyms for fast texting, memorialize them in your journal pages. Alternatively, if you hate, hate, hate certain acronyms or the way some people now say them when they are speaking, journal about that!

Are there blogs you must read every day? These bloggers are your pals, even if you haven't met in person. Print out your must-read blog headers or some of your favorite posts, or the time the famous blogger answered your comment, and journal with them. If you have e-mail pen pals or blog-o-sphere buddies, include your friendship in your art.

Your cell phone pictures may not be ten megapixels, but they are perfect for using in Fauxto Booth strips or Fauxlaroids. You can catch glimpses of your life on the run with your cell camera, and any blurriness or movement adds to the realism of the image. Take pictures of you, your friends and family and even the strangers you see every day, doing just everyday things. Bring your world closer to you through your art.

SOUND OFF:
ARTIST TRADING CARDS

Artist trading cards (ATCs) were started by an artist, as a way to share art. There are no rules about what style of art you have to use, whether you have to paint or collage, or if you have to have a degree in art before making them. In fact, the only rule is their size: ATCs are 2½" × 3½" (6cm × 9cm). And you are free to ignore that rule, if you do not intend to trade them.

As mini journal pages, ATCs can be more than art—they can actually reveal something about the artist. ATCs are a great way to sneak your secrets into the world. If you feel passionate about a cause, put your passion on a card and pass it out. (Be careful where you do that, unless your lawyer is with you.)

These smaller-sized journal pages are perfect for experimenting with abstracts. Try enlarging a photo and using just a portion of it on your ATC. You can paint or draw random shapes on your ATC and add a word or two. Literally play with words: If you are eating cupcakes and must make an ATC about them, note that you are "putting the EAT back in crEATe."

Tattoo

I am art, but my body has none. For this ATC, I trimmed a photo to ATC size and painted over it with concentrated watercolor. I used a font that is "inky in a scary movie kind of way" and added more bursts of color with concentrated watercolor. I drew some tattoos on the legs and used a tattoo rub on.

Staring Contest

For a staring, stopped-time background, I sanded, scratched and dripped concentrated watercolor on a piece of cardstock. I glued on a picture of my eye, cropped from a larger photo. I actually typed my jounaling on newsprint, then glued it with glue stick.

If only I were not afraid of the pain

i always lose staring contests.

Clarity

I used the drippy paint and scratching techniques in bold colors to express a bold moment of clarity. I rubber-stamped the ampersand and some dots with white paint and added lettering with vinyl stickers. I attached clipped text with glue stick.

Listen

Do you hear the trees blowing in the wind? I used the drippy paint and faux spray-paint haze techniques before adding lines and words with a pen. I attached a torn, black-and-white copy of a Fauxto Booth strip and torn newspaper text with glue stick.

In Peace

All that yoga really helped me calm down. I painted a piece of cardstock in deep reds, rubber-stamped the tree and the circle, then attached a photo and decorative paper with glue stick. I then journaled in my own handwriting.

I Don't Really Care

I got tired of being involved in other people's garbage and used art to express that feeling. I sanded and distressed a photograph, then added duct tape and clipped text with glue stick.

SOUND OFF:
FAN MAIL

NO BAD DAYS HERE!

It's fun to get fan mail, and even more fun when the mail really is a fan. We all need a boost now and then, and we all deserve to hear how appreciated and beloved we are. Fan mail shouldn't be for only the famous. Let your friends know you love them. Make someone's day.

Instead of tossing out that promotional fan you got at the mall, make art with it! When you're done cooling off at the mind-numbing football game, use the team giveaway fan to give away some appreciation! You can mail anything (legal) if you put the proper postage on it, so go ahead and mail a fan that expresses why you love your idol. You can use "fan mail" to congratulate a friend on a wonderful performance, whether it was on stage or in private. Your fan mail can applaud a great teacher, honor a sweet voice or salute your most valuable player.

You can find paper fans in any craft or party store. Wooden fans are durable enough to send through the mail uncovered—just address them, stamp them and mail them. Be sure you adhere your embellishments well, of course, and don't use money. If your unwrapped fan arrives a little worse for the wear, that adds to the charm.

No Bad Days

I made this fan for my friend Marlene, wishing her only "cake" days at her job. I painted this white paper fan blue and green to represent sky and grass. While the green paint was still wet, I scribbled into it with the back end of my paintbrush to make texture. When the paint was dry, I attached a photo of cake with Mod Podge, rubber-stamped my words and attached clipped text and an image of a door with Mod Podge. I rubber-stamped polka dots on the handle and added a bit of ribbon before popping it right in the mail.

Linda, Front and Back

Receiving this fan mail from my friend Marlene made my day! Marlene painted her fan yellow, then attached images (the jacket she sees me wearing all the time) and ephemera with Mod Podge. She added texture by rubber-stamping textured elements onto the fan and polka dots on the handle. Marlene rubber-stamped my name and used clipped text for my address. For some jingle, she poked holes in the bottom of the fan and dangled game pieces with ribbon. FUN! She was careful to affix the right amount of postage and wrote my name and address boldly, and the mail-carrier delivered it!

ALLIES

i love you
because
when you say
you know,
you really do.

Allies

Julie is my ally, in light and dark times. We laugh a lot, because when she says she knows, she does. I painted the fan black and, while the paint dried, I printed out an image of Julie. I attached the image to the fan with Mod Podge, then added acrylic paint in big brush strokes around her face. I used my own handwriting, then scribbled all over the fan with a metallic permanent pen. I stuck on vinyl letters to spell out ALLIES, outlined the letters in pen, then peeled them off the fan. I filled in the outlined letter shapes with acrylic paint. I drew around the edges of the fan with metallic permanent pen, then wrapped the handle in duct tape.

Suzi's Fan

Pretty is as pretty does—don't let looks deceive you! Suzi covered her fan with scrapbooking paper and Mod Podge. She distressed the pretty paper by stamping texture on it with permanent ink and metal tape. She created a charming yellow card with crystals and flowers to convey her message and secured the card to the fan in a grungy envelope. She wrapped the handle in metallic tape.

THE ART ARMY

Share your art with the world! Take up artful arms and join your comrades in artistic insurrection. We proudly stand paint covered hand-in-paint covered hand with the growing members of our Art Army. Join us.

START
START
START

I never had a chance to know you. But I'm kind of glad I didn't

001122

A FOLDED BLANKET

Folded Blanket

Christine Polomsky
Erlanger, Kentucky

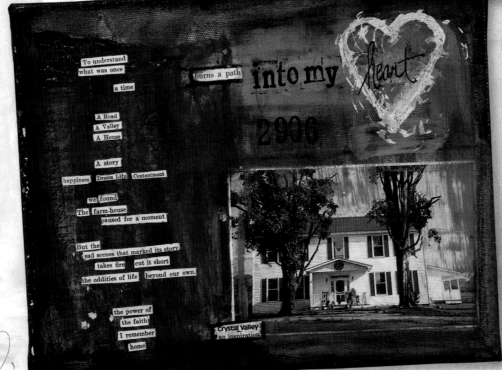

into my heart
2906

To understand
what was once
a time
burns a path

A Road
A Valley
A House

A story
happiness Dream Life Contentment

we found
The farm-house
paused for a moment

But the
sad scenes that marked its story
takes fire cut it short
the oddities of life beyond our own.

the power of
the faith
I remember
home

Crystal Valley
an inspiration

2906

Marissa Bowers
Lebanon, Ohio

120

Jonah's Birthday

Erika Tysse
Stavanger, Norway

Irrational Fears

Suzi Finer
Beverly Hills, California

Running Away

Holly Dye
Granada Hills, California

The Spice of Life

Tonia Davenport
Mason, Ohio

Can't Sleep

Roben-Marie Smith
Port Orange, Florida

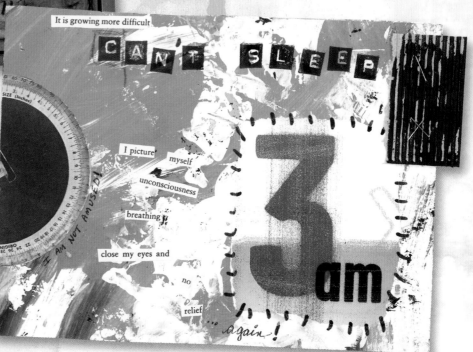

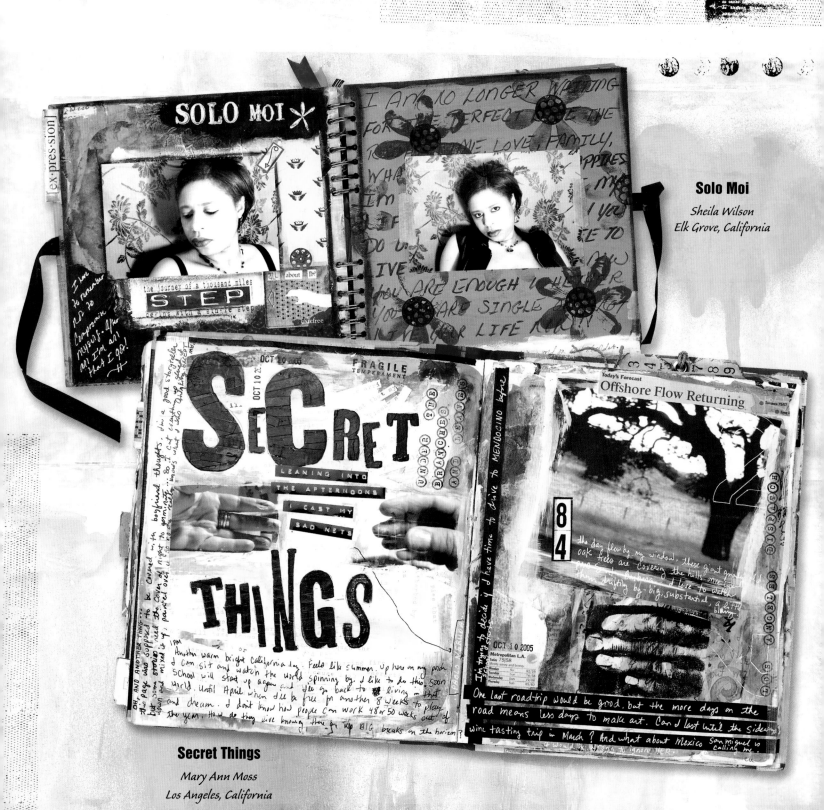

SOLO MOI

I live to remember not to compromise myself. Here am I am I as I go!

the journey of a thousand miles begins with a single step **STEP**

all about me
carefree

I AM NO LONGER WAITING FOR THE PERFECT... LIFE... LOVE, FAMILY... WHAT I'm... IF... DO U... IVE... YOU ARE ENOUGH WHETHER YOU ARE SINGLE OR NOT IN YOUR LIFE...

Solo Moi

Sheila Wilson
Elk Grove, California

FRAGILE TEMPERAMENT

OCT 10 2005

SeCReT

LEANING INTO THE AFTERNOONS I CAST MY SAD NETS

UNDER THE BRANCHES AND LEAVES

THINGS

Today's Forecast
Offshore Flow Returning

8 4

OCT 10 2005

One last roadtrip would be good, but the more days on the road means less days to make art. Can I last until the side... wine tasting trip in March? And what about Mexico...

Secret Things

Mary Ann Moss
Los Angeles, California

ROSIE O'DONNELL
words + art

say whatever it is u need

when painting
there is a point
u must step away from
the canvas
as the work
is done

any more would take away

there r no mistakes
in art
fear not feelings
friend

so u know
i think all my collages
r horrid

i don't try to hide the tape
i use it boldly

get some paint
some old clothes
and go to town

life is messy

TO LOVE
SMILE
RELAXATION
POSITIVE
PLEASURES

wait till u
find ur collages
a yr from now
it will bring u
back to that
moment in time

amazing

collage
scotch tape
magazines
on a post card

art is flowing

there is no perfect art

FEB 19 — MAR 24

125

RESOURCES

Autumn Leaves
www.autumnleaves.com
rubber stamps

Creative Chaos Rubber Stamps
P.O. Box 3695
Fontana, CA 92334
www.vickieenkoff.com
rubber stamps

Creative Imaginations
17832 Gothard Street
Huntington Beach, CA 92647
www.creativeimaginations.us
paper, rub-on lettering

Dr. Ph. Martin's
301 Commercial Road, Suite H
Golden, CO 80401
www.docmartins.com/
craftInk.asp
800-384-3588
concentrated watercolors

Elmer's
www.elmers.com
800-848-9400
glue

FiberScraps
82 Windover Lane
Doylestown, PA 18901
www.fiberscraps.com
215-230-4905
walnut ink daubers

Fiskars Brands, Inc.
2537 Daniels Street
Madison, WI 53718
www.fiskars.com
866-348-5661
scissors and paper punches

Green Pepper Press
www.greenpepperpress.com
rubber stamps

Paperbag Studios
6218 Morning Drive
Port Orange, FL 32127
www.paperbagstudios.com
386-304-8617
rubber stamps

Plaid
www.modpodge.com
800-842-4197
Mod Podge

Sanford
www.sanfordcorp.com
800-323-0749
*permanent pens, correction
fluid pens, Rolodex*

Saunders
65 Nickerson Hill Road
Readfield, ME 04355
www.saunders-usa.com/uhu/
800-341-4674
glue sticks

Stewart Superior
2050 Farallon Drive
San Leandro, CA 94577
www.stewartsuperior.com
800-558-2875
ink pads

Tsukineko, Inc.
17640 NE 65th Street
Redmond, WA 98052
www.tsukineko.com
425-883-7733
StazOn ink pads

3M
3M Corporate Headquarters
3M Center
St. Paul, MN 55144-1000
tape

Contributing Artists
Marissa Bowers
www.issadesign.blogspot.com

Tonia Davenport
www.toniadavenport.typepad.com

Holly Dye

Suzi Finer
www.suzifiner.com

Marlene Hazlewood
joymarlene@aol.com

Mary Ann Moss
www.dispatchfromla.typepad.com

Rosie O'Donnell
www.rosie.com

Christine Polomsky

Roben-Marie Smith
www.robenmarie.blogs.com

Erika Tysse
www.erikatysse.com

Sheila Wilson
www.sheilamichelle.blogspot.com

INDEX

EXPAND YOUR CREATIVE TERRITORY FURTHER WITH THESE NORTH LIGHT BOOKS TITLES

THESE AND OTHER NORTH LIGHT BOOKS ARE AVAILABLE AT YOUR LOCAL CRAFT STORE OR BOOKSTORE, OR FROM ONLINE SUPPLIERS.

VISUAL CHRONICLES
Linda Woods & Karen Dinino

Have you always wanted to dive into art journaling, but intimidation and fear held you back? *Visual Chronicles* is your no-fear guide to creative self-expression, using words as art and artful words. You'll learn quick ways to chronicle your thoughts with painting, stamping, collaging and writing. Friendly projects like the Personal Palette and the Mini Prompt Journal make starting easy. You'll also find inspiration for experimenting with colors, shapes, ephemera, communicating styles, symbols and more!

ISBN-10: 1-58180-770-8 ISBN-13: 978-1-58180-770-7
paperback 128 pages 33442

WIDE OPEN
Randi Feuerhelm-Watts

Open yourself up to a whole new way of looking at yourself, your world and your art journaling. The *Wide Open* book and deck set is all about challenging yourself to take your art to the next level. The set includes 50 idea cards featuring mixed-media artist Randi Feuerhelm-Watts's art on one side and thought-provoking instruction on the other, plus a journal for recording your ideas and artwork.

ISBN-10: 1-58180-911-5 ISBN-13: 978-1-58180-911-4
50-card deck in a box with accompanying 64-page journal Z0653

KALEIDOSCOPE
Suzanne Simanaitis

Get up and make some art! *Kaleidoscope* delivers your creative muse directly to your workspace. Featuring interactive and energizing creativity prompts ranging from inspiring stories to personality tests, doodle exercises, purses in duct tape and a cut-and-fold shrine, this is one-stop shopping for getting your creative juices flowing. The book showcases eye-candy artwork and projects with instruction from some of the hottest collage, mixed-media and altered artists on the Zine scene today.

ISBN-10: 1-58180-879-8 ISBN-13: 978-1-58180-879-7
paperback 144 pages Z0346

LIFELINES
Carol Wingert and Tena Sprenger

"Take plain old scrapbooking to a new level of artfulness." *Lifelines* features 30 projects, including handmade books, wall art and scrapbook pages, that use the latest techniques in papercrafting and altered arts. You'll learn how to capture the importance of significant relationships that deepen and grow during average everydays, not just at birthday parties and weddings. Authors Carol Wingert and Tena Sprenger show you how to create meaningful memory art that chronicles your day-to-day life and the lives of your loved ones.

ISBN-10: 1-58180-886-0
ISBN-13: 978-1-58180-886-5
paperback 128 pages Z0495